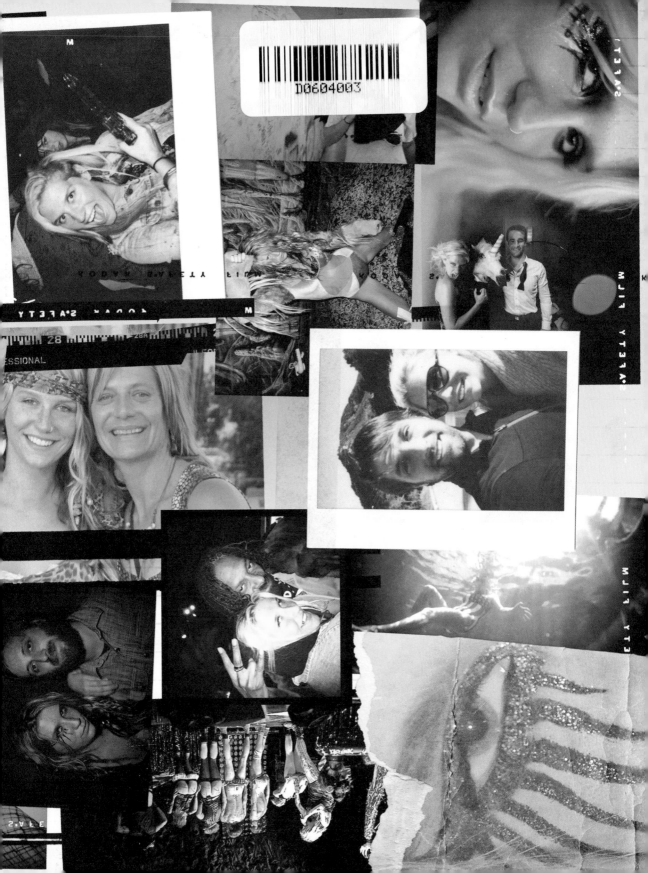

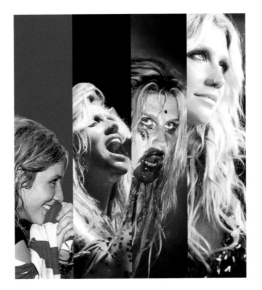

MY CRAZY BEAUTIFUL LIFE ✕ KE$HA

WITHDRAWN

A TOUCHSTONE BOOK
PUBLISHED BY SIMON & SCHUSTER
NEW YORK LONDON TORONTO SYDNEY NEW DELHI

 ★ Touchstone
A Division of Simon & Schuster, Inc.
1230 Avenue of the Americas
New York, NY 10020

First Touchstone hardcover edition November 2012

TOUCHSTONE and colophon are registered trademarks of
Simon & Schuster, Inc.

For information about special discounts for bulk purchases,
please contact Simon & Schuster Special Sales at
1-866-506-1949 or business@simonandschuster.com.

The Simon & Schuster Speakers Bureau can bring authors to your
live event. For more information or to book an event contact the
Simon & Schuster Speakers Bureau at 1-866-248-3049 or visit
our website at www.simonspeakers.com.

Designed by The Uprising Creative

Manufactured in the United States of America

10 9 8 7 6 5 4 3 2 1

Library of Congress Cataloging-in-Publication Data
Ke$ha.
My crazy beautiful life / Ke$ha.
—First Touchstone hardcover edition.
192 pages ; cm
"A Touchstone Book."
1. Ke$ha. 2. Singers—United States—Biography. I. Title.
ML420.K368A3 2012
782.42164092—dc23
2012027632

ISBN 978-1-4767-0416-6
ISBN 978-1-4767-0419-7 (ebook)

FOR MY ANIMALS

INTRO

I was sitting on a rock above crashing waves as I looked out on the endless horizon with nothing but a pen and a blank notebook. At the end of 2011, I was a thousand miles away from the nearest stage, on a remote beach on the Galápagos Islands, and in some weird way, this was the place I had been trying to get to since I was a little girl. At this moment, at the beginning of my vacation, after finishing my *first* world tour, off of my *first* full-length album, *Animal,* I was finally alone with my own thoughts and had enough confidence to admit to myself that I had done it. I had achieved the only thing I had ever wanted to do: I had made music that had reached millions of people and then traveled the world playing it.

I was never the popular kid growing up. I was the weird girl with homemade clothes, writing song lyrics in my textbooks in the back of class. I know how it feels to be bullied; I know that it can stay with you for a long time. But I always had a dream and a determined mind. I was taught to just give the haters the finger and to try harder whenever anyone doubted me. If I had listened to any of the cynics along the way, I would have been going against my whole reason for living.

In less than three years, I've gone from being the worst waitress in LA to a multiplatinum-selling artist. Sometimes, it feels as if the last few years have encompassed a few decades. Writing my first album, I was just a wild party animal. I was broke, but I had a totally uninhibited and carefree lifestyle. When my first single, "Tik Tok," hit the radio and broke sales records, fame took me from a listless lifestyle in a Laurel Canyon flophouse and carried me on a magical and sometimes rudely awakening journey. I was so naïve: at the beginning, I had no idea what I was in for. I was just trying to keep my eyes open and hold on.

You might have heard my voice on the radio, seen me onstage and on the red carpet, or in a music video, but that's only a part of the story. In these pages, I'm revealing a more complete picture of what my life is really like. It's not all glamorous and it's not all pretty, but it's all real.

First and foremost I'm a writer: that's what has gotten me this far, and that's what I'll be doing till I die. I especially wanted this book to open a window into my creative process as I put together

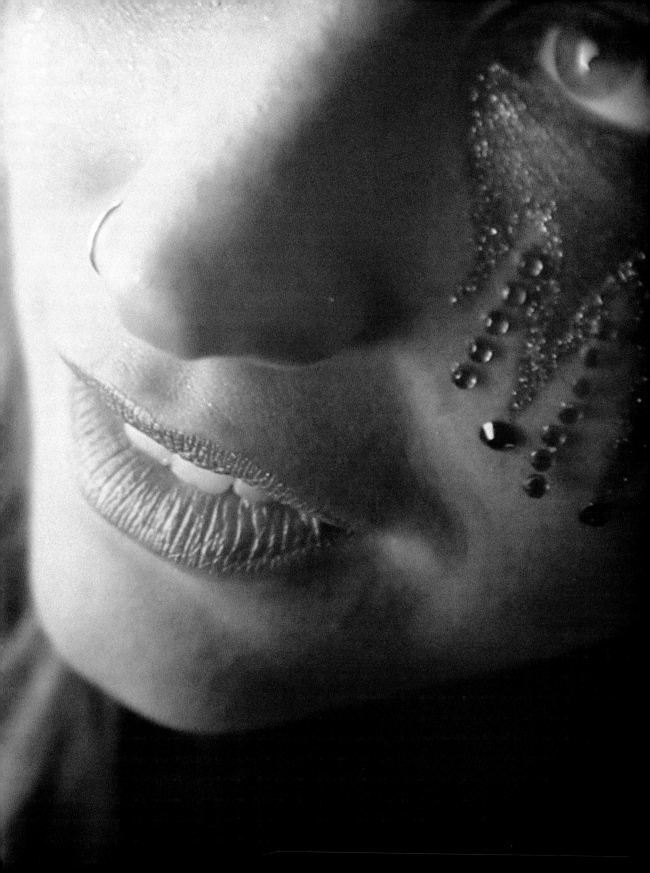

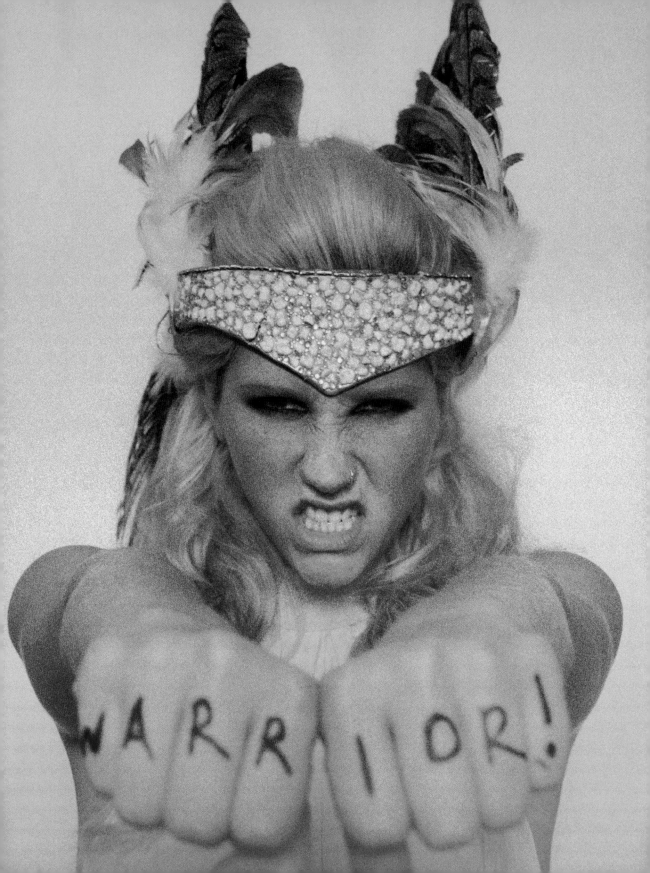

my sophomore full-length album. Writing is the part that often goes on under the radar, but for me, it's the most important thing.

I have had some incredible highs over the last few years, but my life isn't perfect. Sometimes the road can be lonely and I've had moments of weakness. I can recall multiple times when I had to drag my sleep-deprived body onto the stage, my throat feeling like I had just swallowed a handful of razor blades. I missed my family and friends and having a normal life. Then, almost on cue, one of my amazing animals would bring me a scrapbook or a piece of artwork and tell me that my music had helped him or her get through some tough moments. Instantly, I'd be reenergized and know that I am doing exactly what I was supposed to be doing.

I've gathered my favorite photos, notebook pages, and lyric sheets together here with some of my memories and thoughts. Even though this is just the beginning of my story, after having had an opportunity to reflect on this wild ride, I wanted to share it with the people who have made it all possible: MY INCREDIBLE ANIMALS! This book is for my fans—for the freaks, the mad ones, the passionate dreamers, the crazy kids, and the animals who every single night live life as if it were the last night of their lives.

Sitting there watching the waves crash on the beach made me realize how everything is temporary. It all comes and goes. It made me appreciate all the photos that my brother and the rest of my family and friends have taken throughout this crazy adventure around the world. When I started sifting through these images, it brought back all of my memories from the very beginning.

I want you to come on a whirlwind journey with an all-access pass to My Crazy Beautiful Life: from "Right Round" through the completion of my new album. Some of my most memorable moments over the last few years include the time when I lost my voice the day before I played the main stage at one of the biggest music festivals in the world; hanging out with Alice Cooper and his snake; hallucinating onstage after three days without sleep; singing, writing, creating, arguing, and living in the studio with Dr. Luke; hang gliding in Brazil; traveling to Hungary, the country of my ancestors, and playing the biggest show of my life in the central square of Budapest as the sun set over the horizon; writing one of my favorite songs I've ever written in a burst of creativity at my piano in Nashville; and of course my long-awaited vacation to the Galápagos.

As I sat there on that rock in the middle of the ocean, in a place stuck in time, I was smiling, but I knew that the biggest challenge of my life was staring me in the face. I knew that if I didn't rise to the challenge and write a spectacular sophomore album, my career could be short-lived. I took a deep breath, meditated, and felt the wind hit my face.

I looked at the blank page and realized that I was right back where it all started, a girl with a crazy dream and a notebook. I took my pen and wrote one word: warrior.

Whatever the future holds, I'm ready for it. See you there!
—Ke$ha
July 2012

MY CRAZY BEAUTIFUL LIFE

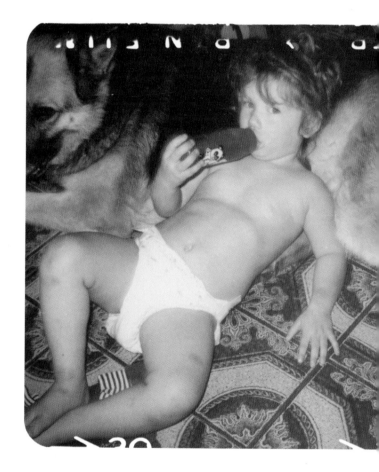

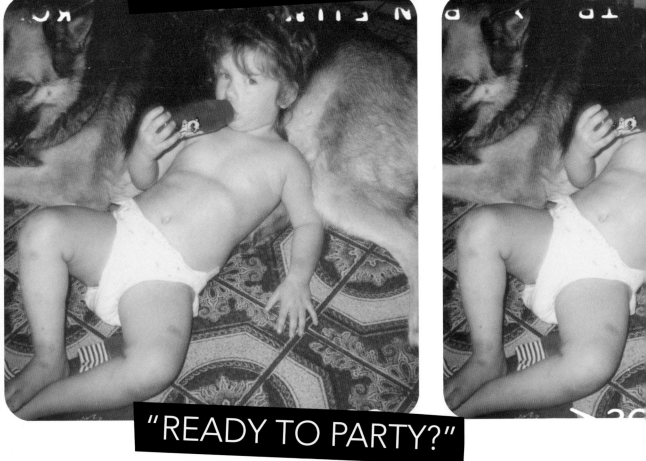

WAY BACK WHEN

I WAS BORN A WILD CHILD WITH AN AFFINITY FOR BODY PAINT. AS YOU CAN SEE I'VE HAD PLENTY OF ATTITUDE SINCE I WAS A BABY. AND, YES, THE DOLLAR SIGN IN THIS PICTURE IS REAL.

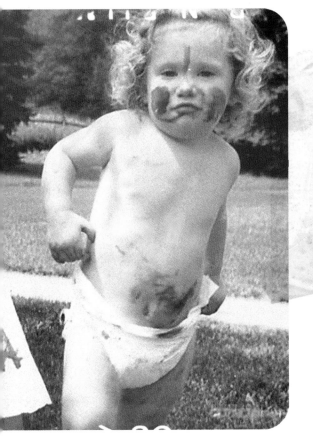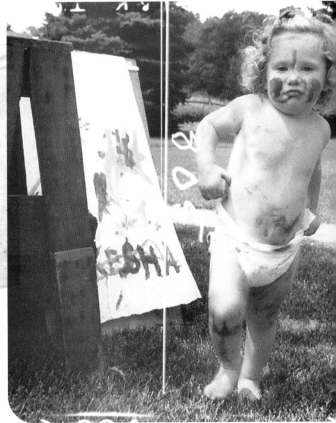

I WAS BORN AT A PARTY ... LITERALLY

In 1987, my mom was pregnant with me and living with my older brother, Lagan, in a slanted duplex in Van Nuys, California, just north of LA. Mom didn't believe in giving birth in a hospital. When she started to go into labor, the first thing she did was invite all of her friends over to keep her company. Then, she called her midwife, who didn't think that I was about to come out, probably because she could hear a party going on in the background.

Obviously, the midwife underestimated me. I'm not one to miss a party. It only took a few minutes before my mom's best friend, Mindy Rumph, delivered me into the world. Mindy handed me to my mom, not knowing what else to do. My mom says that I opened my eyes, looked right up at her, and smiled as if I'd been waiting to see her for a long time.

When I was little, it was just my mom, my brother, and me. Before I was born, my mom wanted to have another child, but she didn't want to be in a relationship. Because some sperm banks had reportedly been infected with HIV, my mom decided to ask some of her friends to try to get her pregnant.

I've never known for sure who my father is, and I don't want to know. My mom played both parental roles for us growing up, while struggling with her own career as a singer and songwriter.

Mom never lets other people's opinions get in the way of what she wants. My entire family is fiercely independent that way.

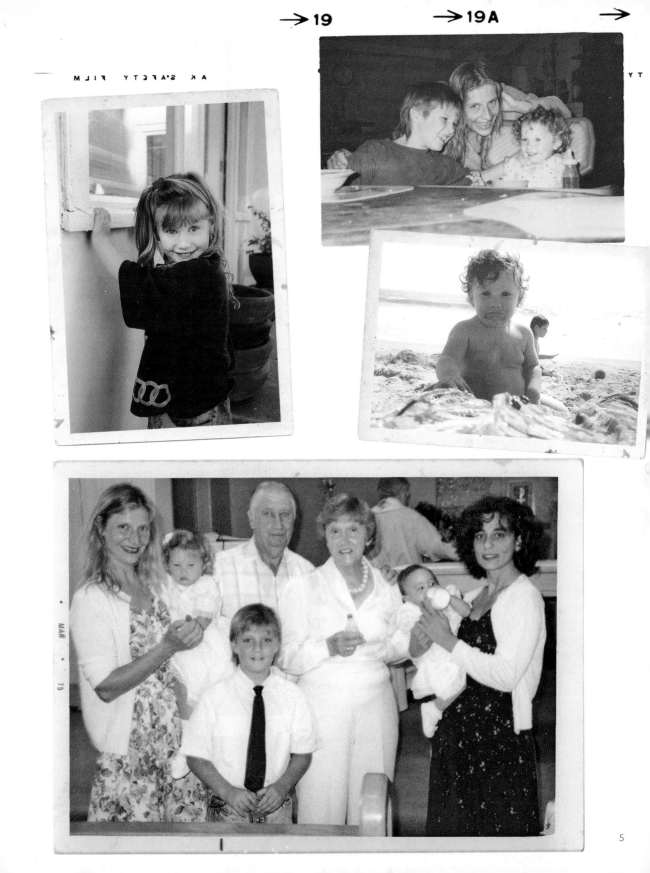

We didn't have money, but we were happy. I think that's why there is an underlying message in my music that fun and happiness are never dependent on how much money you have.

My mother is a true free spirit. To this day, she rarely wears shoes, and she once lived in a broken-down bus in the woods of New Hampshire. Fun was never undervalued in our household. If we were too broke to go shopping, my mom would take us to Beverly Hills and we would look for discarded treasures on the side of the road. It's amazing the things that people will throw out. When I was little, we furnished our entire house this way. Some of my happiest childhood memories are from breaking into Universal Studios at night through a hole in the fence and jumping in the fountains to gather all of the quarters people had thrown in, or sneaking into the movies because we didn't have money to pay, or stealing fruit from neighborhood trees to make breakfast. I remember it being fun to be broke when I was a kid. It made me the scrappy and crafty person I am today.

We were always surrounded by music and eccentric musicians, so in some ways my life hasn't changed that much from when I was a kid.

My mom taught me to question every rule and encouraged me to be the person I wanted to be and to be proud of who I am. I think I owe a lot of my success to that.

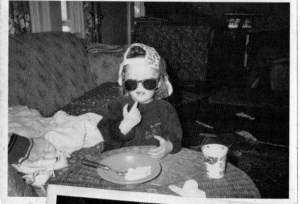

My brother Lagan and I are probably as close as any siblings separated by six years could be. When we were young, and struggling for cash, we moved houses every year or two, and my brother and I were constantly switching schools. We leaned on each other for support. It taught us to stick together.

Lagan and I shared our love for music. I remember Lagan playing in crappy garage bands growing up, and I was fascinated by it, even though they mainly just sounded like noise. He schooled me on rock and roll, punk, and hip-hop. He introduced me to Fugazi, Beastie Boys, Sonic Youth, Beck, Outkast, and Tennessee garage rockers Greg Oblivian and Jay Reatard.

When I got older, Lagan and I formed our own garage rock band, called Dynamite Cop. When I moved out to California, Lagan and I shared an apartment for a few years, and we continued to make music together. Making music with my brother was just about having fun and seeing how creative we could get. We would stay up all night in our one-bedroom apartment overlooking Sunset Boulevard, fire up our laptops, and bang around on every instrument we could get our hands on until we had a song. Whenever we can find a few guitars and a few free moments, my brother and I still love to rock out, drink some whiskey, and see how long it takes before someone calls the cops.

My little brother, Louie, was born when I was in middle school. He's a little badass and the coolest kid I know.

But he's still my little brother, so naturally I've come pretty close to strangling him on a few occasions. When Louie was younger, he was obsessed with my glitter. I would come home from school to find him covered in my most expensive glitter, riding around the house at a hundred miles an hour on his pink, hand-me-down scooter, armed with a Nerf gun that he used to defend himself from me. He was a good shot, too. The kid is lucky to be alive.

My mom homeschooled Louie for a year so that they could both come on the road with me. Louie became something of a legend on the tour circuit. He loved waking up every day in a different city and running around empty auditoriums. Louie would challenge the local crews to soccer matches when they were supposed to be building the stage and getting things ready for the show. At the 2011 Future Music Festival in Australia, he beat everyone at Ping-Pong—from MGMT to the Chemical Brothers crew. Louie is a drummer, and during my shows he would sneak onto the stage, climb up the platform to talk to my drummer, Elias Mallin, and watch what he was doing—that is, until a crew member would notice and yell at him to get off the stage. Louie reminds me a lot of myself when I was his age; he is fearless and dead set on getting his way.

My cousin Kalan (or Quay-Quay) is a frisky little $hit.

We're only a year apart in age and she's like a sister to me. We live vicariously through each other—she's always bringing me back to reality, and I'm always challenging her to try new, questionably stupid things. I've convinced her to

do everything from jumping off cliffs to letting me give her a prison tattoo of a whale on her foot after a long night of partying.

9

When I was young, we had an old, yellow cargo van with a bed in the back. It was like a poor man's Winnebago. We would take it across the country, exploring new places and visiting my mom's hippie friends all over the country. My mother always took us on adventurous vacations even when we were broke. We would drive through the American Southwest or take family vacations to Mexico, where we would ride around the country on chicken buses. We didn't speak Spanish. It never mattered.

It was perfect training for my current lifestyle. Even though it can be exhausting, I love touring. My schedule is packed on the road, but I always make time to take a run through the countryside, hit the local metal bars, and make out with foreign dudes.

I'm a big fan of souvenirs. My assistant has gotten stuck lugging everything from vintage lamps, oversize candleholders, rotary telephones, to decorative rocks all over the world. Not to mention the hundreds of human teeth I've been collecting from my fans over the years. Sorry, Tessa . . . I love you . . .

I've always felt connected to animals. And, yes, I include dinosaurs in this category. I think I wrote my first song about dinosaurs around age five. I wrote my most recent song about dinosaurs (aka greasy, scummy, old dudes) at age eighteen and it probably won't be the last either.

We are a family of animal lovers. Growing up, we always had rescued dogs. That's why I was so excited to become the first global ambassador for Humane Society International. HSI does important work to protect animals all over the world. The organization is on the front line fighting to preserve delicate natural habitats, such as forests and coral reefs where so many endangered species live. I believe that all living creatures are connected, and if we lose any of these animal species, we lose a part of ourselves.

EVER SINCE I CAN REMEMBER, I WAS ALWAYS SURROUNDED BY MUSIC.

My mom is an amazing songwriter. She's written beautiful songs for artists such as Dolly Parton and Johnny Cash. In 1985, she moved from Nashville to LA to work on a New Wave album, which to this day sounds badass.

She opened up for the Red Hot Chili Peppers before anyone knew who they were.

Some of my earliest memories are of being at my mom's gigs around LA and falling asleep in the guitar cases on the side of the stage.

As soon as I could hold a microphone, I never wanted to put it down. I carried around a plastic, pink Echo microphone the way other kids carry around their favorite stuffed animal or blanket. When I was five, we moved back to Nashville. By the time I was about twelve, my mother started letting me sit in on her songwriting sessions. Soon, I was singing my mom's songs for her in demo sessions whenever I could. I loved being in the studio.

My mom taught me to write honestly and tell a good story. Writing songs was, and is, my favorite thing to do in the world. When I wasn't in

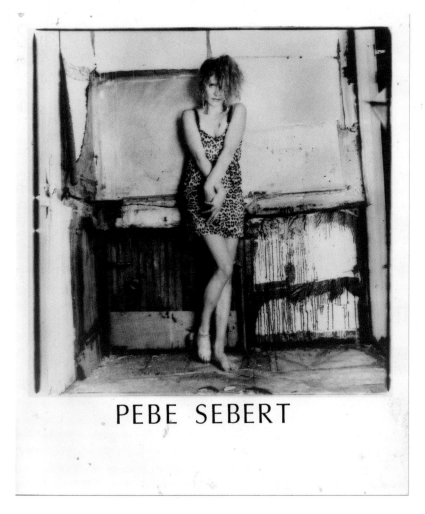

PEBE SEBERT

the studio with my mom, I'd be sitting with a guitar and a notepad scribbling lyrics. I always get the greatest rush from songwriting. It's a natural high that's better than anything else.

Music was and is my whole life. When I wasn't in the studio or at school, I was running around Nashville listening to live music. In high school, I had a bit of a reputation for sneaking into shows. One Nashville rock venue in particular, the Exit/In, didn't take kindly to my antics. I would sneak in multiple times a week, and no matter what they did, I could always find a way to get in. It was like a game. I didn't even care who was playing. I just wanted to get in to prove that I could stick it to the man. It pissed the owner off so much. Eventually, the owner took one of my confiscated IDs and blew it up into a huge picture and posted it all over the venue with a giant red *X* drawn across my face. But that still didn't stop me. I would show up during sound check and make out with a roadie or slip in the back door.

I'm a sneaky bitch.

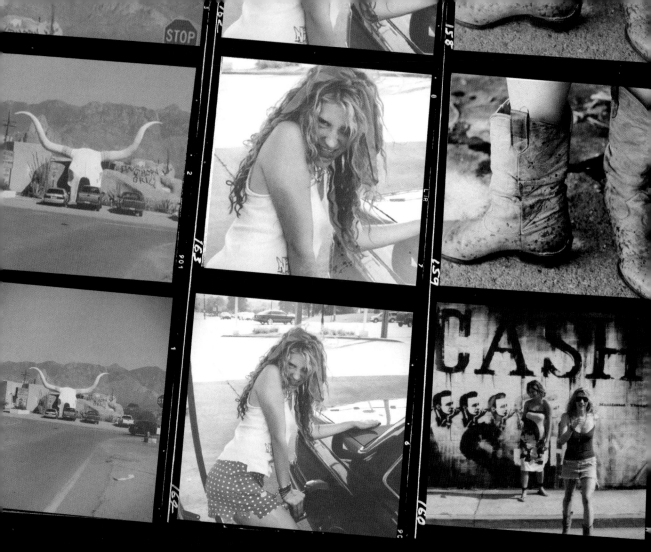

I was a good student in high school. I'd been accepted to Ivy League schools when I got a call that changed my life. My mom had recently given my CD to Samantha Cox, her friend who worked at BMI. Sam liked the CD, so she sent it to a producer who had recently broken out with the Kelly Clarkson single "Since U Been Gone." His name was Dr. Luke. Luke called my house and told me that he was looking for a young artist to work with. He thought that I might be the person he was

Luke said that he believed in me, but if I wanted to make it, I needed to come out to LA and make myself available to work with him whenever he could fit me into his schedule.

I knew that there were no guarantees in the music business, but I also knew what I wanted. I wasn't going to be satisfied with anything else. So I threw away my college acceptance letters, dropped out of high school, fueled up my grandpa's old Lincoln town car, and drove west in

KESHA SEBERT'S MYSPACE BIO CIRCA 2005:

The illegitimate child of a punk rocker tried to behave for a while, and then finally gave up. That's when it got interesting. After escaping Catholic school, I began my adventures indulging in my angsty adolescence. I decided to create an anthem of my youth. Songs to get fucked up to, songs for broken hearts. I love cowboys, synthesizers, and boys that wear their pants too tight and curse like sailors. I loathe pretentious Hollywood idiots. I write about what I know: Nashville, making out with rock stars, amateur stalking. I play the harmonica, dabble with the Dobro and have been trained in opera since I was young. I am afraid of squid and other slimy underwater creatures. I am not afraid to take karaoke very seriously. I like boots. I rock spurs. My intentions are to take over the world. I am not stupid, but yeah . . . I am blonde. I could totally kick your ass.

xoxo

p.s. My name is Kesha.

I was seventeen and alone in LA. I stayed with family friends and looked for work to keep enough gas in the car to take me to and from writing appointments. By the time I made it out there, Dr. Luke was fast on his way to becoming one of the most sought-after producers in the world. He was booked solid. I ran around the hot LA streets writing songs every day and looking for people to make music with.

So many people told me that I wasn't going to make it, but that just fueled my fire even more. I have a pretty well-documented history of going to extreme measures to get people to listen to my music. Yeah, I broke into Prince's house to drop off one of my CDs, but I also hunted down dozens of other people I respected such as the Dust Brothers and Beck to try to get them to work with

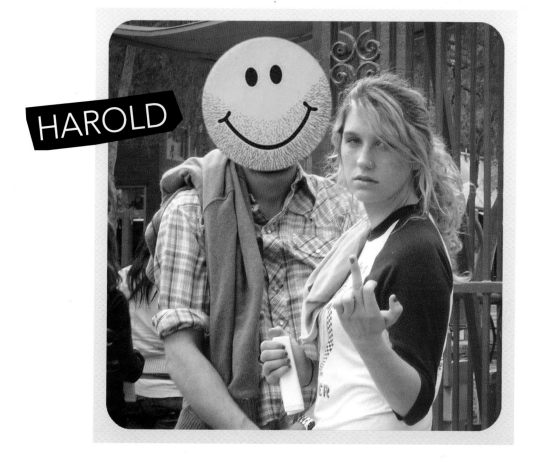

me. One time when I saw P. Diddy at a restaurant, I walked right up to him, handed him a CD, and told him that it was going to be the next new sh$#. He probably just thought I was some psychotic girl—little did he know that he'd be on one of my songs in a few years.

A few of the producers I sought out agreed to work with me. One of the first was David Gamson, who was famous for his work with the postpunk band Scritti Politti. Together, we worked on the songs "Stephen," "Backstabber," and "C U Next Tuesday." But even though I was making music I was proud of, it wasn't exactly paying the bills. I went through jobs the way most people go through outfits. I was a TV extra, a telemarketer, a hostess at a club, I handed out postcard advertisements on Venice Beach and I was a barback until they realized I wasn't twenty-one and was snagging IDs that other blond girls left at the bar to add to my collection of fake IDs. Over the years I also managed to become the worst waitress in LA and possibly the world.

Then one day while handing out flyers for some DJ party, I met a tall, bearded man named Harold.

Harold swept me off my feet and took me in like a stray. It was crazy love from the start. He was my first love and has been one of my muses ever since.

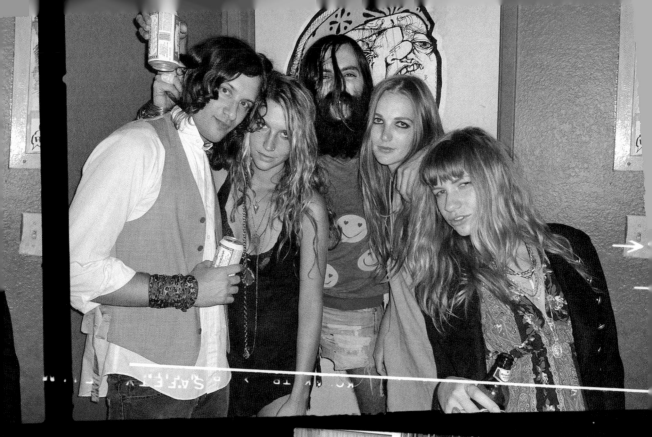

→ 30

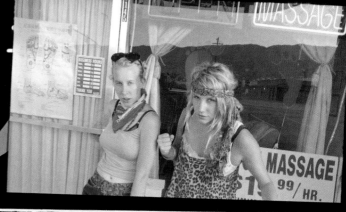

→18A →19 →19A →

EVENTUALLY, I FOUND A GROUP OF CREATIVE FRIENDS IN LA WHO WERE JUST AS CRAZY AS I WAS.

We were a bunch of wild gutter punks roaming around Echo Park, trying to get in as much trouble as we could find. We all had big dreams, but no money. We lived off tequila and fury. I wrote much of my first album about those days. I would come home early in the morning after partying all night and go straight into my room, open up GarageBand on my laptop, and write songs about whatever had just happened that night. I wrote hundreds of songs. It was my form of therapy. Those old songs are the ones that I was constantly updating my Myspace with, and my audience started to grow. A few hundred and then a few thousand people would play my songs on Myspace and send me messages; it may have seemed small, but that kind of encouragement kept me going.

Then I got a call from Dr. Luke. He needed someone to sing on a Flo Rida song. The song, "Right Round," went to the top of the charts across the world and broke the record for most digital sales in a week. When I first heard it on the radio, I pulled my car over, turned up the radio, and started crying. It was finally happening.

I didn't make a dime off the song, but it didn't matter. I would walk around and hear my voice coming out of car windows, storefronts, and bars, yet I still didn't have any money. One day, I was with my friends at one of our favorite dive bars. The place had mirrors on the ceiling, a gold bar room, $1 tequila shots, and free tacos . . . I mean, why wouldn't you want to hang out there? We all ran out of money and were scrounging for change to buy more tequila when "Right Round" came on the radio. I licked the salt off my hand, took my last tequila shot, and then it hit me: I'm putting a dollar sign in my name.

Putting the $ in my name was my way of saying I am money. Nothing was going to stop me and no one was going to bring me down. Even though my friends and I were broke, we could still find a way to have the best night of our lives every night. Now, I love that when some people see the dollar sign, they don't just think about money, they also think about debauchery, Jack Daniel's, and glitter.

ALL OF A SUDDEN IT WAS HAPPENING.

After years of scrounging around LA and writing hundreds of songs by myself or with anyone who would write with me, suddenly now people were coming to me. I got multiple record-contract offers, but ultimately decided to sign with Dr. Luke's label, Kemosabe Records, at RCA Records. But before I signed on the dotted line, I had one request: I needed a car. "Any car?" they asked. "No, I need a 1978, gold, T-top Trans Am," I replied.

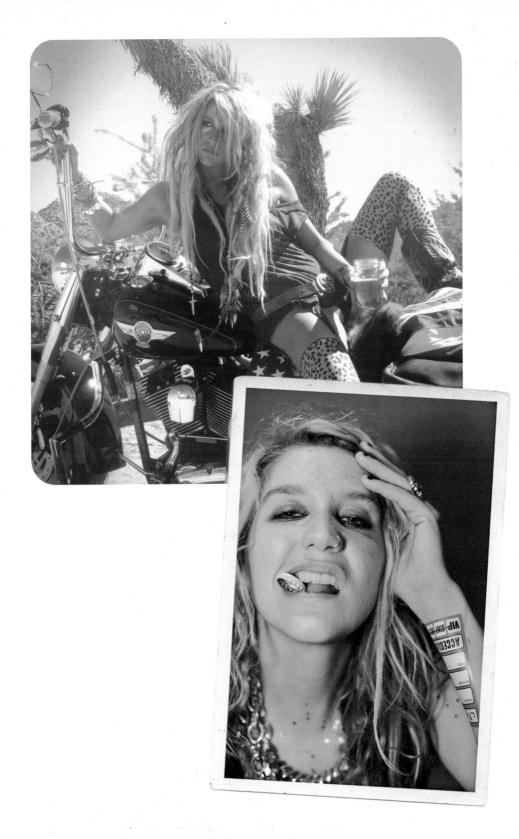

Here I am with Dr. Luke and his crew—Kojak, Max Martin, Benny Blanco, and Ammo. They're some of the most creative people in the music business. During the recording of my debut album, they became my crew as well. I worked so much that I pretty much lived at the studio. We would be writing three songs at a time in different rooms, then we'd go out, get drunk, come home, and write another one.

I had so many great songs that I had already done by myself, but Luke brought something new and fresh to my sound, and he encouraged me to be bold.

Luke introduced me to Benny Blanco, and we instantly vibed. He was hypercreative and reminded me of my crazy wild child friends. We're the same age and we played just as hard as we worked. I was in New York at Benny's apartment when he played me a track idea he had. It sounded

hard and I liked it. I started writing lyrics, and Benny started playing some gnarly synth sounds. We were drinking whiskey and apple juice with a splash of vodka. And "Blah Blah Blah" was born.

I've never censored myself for anyone, but when writing that song in particular, I decided that I wanted to talk about men the way men talk about women. I wanted to level the playing field. I'm a young, responsible woman who can work and party as hard as any man. So, if I want to talk about drinking and sex, I'm going to do it. Three hours after we started, the song was written.

I had to leave the next day to go back to LA to work with Luke, so we decided that we would go out to celebrate for a few hours and then do the final vocals in the morning. We ended up partying all night, and when the sun was coming up, instead of going back into the studio to finish the song, we decided to take the train up to Harlem to

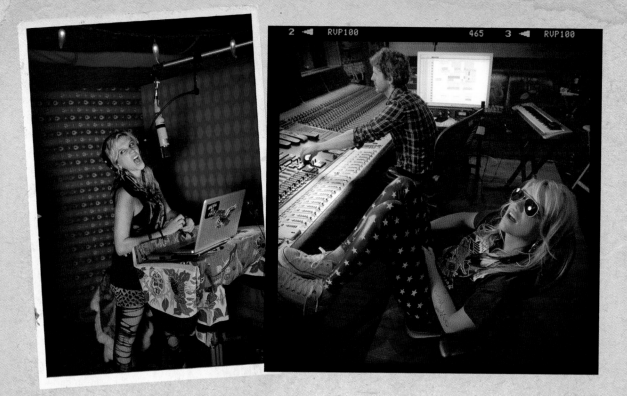

get tattoos. Benny said that if I got a tattoo, he'd get one, too. I got not one but two tattoos—a skull and crossbones and the infamous dollar sign on my hand. Benny wimped out like a little bit¢h.

When I got back to LA and Luke heard what Benny and I were working on, he got excited and said we needed more stuff like that.

A few days later, I had a particularly long night with all of my girlfriends, and when I woke up, all these beautiful half-naked women were lying around me, and I thought to myself this must be what P. Diddy feels like every day. At the time, I was living in a big house with about fifty other people in the Hollywood Hills. Everyone in the house lived this carefree lifestyle and was out to have fun all the time. I decided I wanted to write a song that celebrated the listless lifestyle of a broke and reckless LA wild child.

That day I went into the studio and told Luke

I had an idea. Benny and Luke had a track that I liked, and we got down to business. Later that same day, as fate would have it, P. Diddy called Luke wanting to collaborate on something. Luke invited him to the studio, and P. Diddy came over. By the time P. Diddy put down his part, the song was finished, and Luke was confident that we had the first single.

When recording was almost done, I went back to Nashville to work a little more with my mom. On the plane, I couldn't stop thinking of Harold. I felt like some kind of addict in withdrawal; his love was like a drug. I started writing lyrics, and in twenty minutes I had a rough version of "Your Love Is My Drug." Some songs just happen like that. The next morning I woke up and showed my mom what I had written and we finished it that day in under an hour.

MY TEAM

Animal shot to the top of the charts as soon as it came out, and "Tik Tok" reached number one in eleven countries, breaking the record "Right Round" set for the most digital sales in one week. Things were starting to blow up before I even had a band. All of a sudden, I was getting offers to play massive venues. So I called up one of my oldest childhood friends, Lauren. "Do you think you could play a keytar?" I asked. She played about a dozen other instruments and felt pretty confident that she could figure out the keytar. I had about ten thousand guitar players try out before I found Max Bernstein. He shredded on the guitar and made me laugh, so I told him he had the job on one condition: he had to agree to grow a mullet and a beard. He obliged, and now I am the boss of Max's hair! More on that later.

I was flying around the world playing every show I could, stumbling awkwardly in high heels down red carpets, and cursing my way through interview after interview. Luckily, I had my team to get me through it and clean up my hotel rooms! I wouldn't have survived those early days without my manager, Emily Burton, who protected me as if I were her little sister.

SNL -

scariest thing
EVER -
lazer harp didn't
work -

I went from having five to twenty people at my shows to five thousand to twenty thousand almost overnight. The second time my band ever played live together was at Lollapalooza. Fukkin *Lollapalooza*!

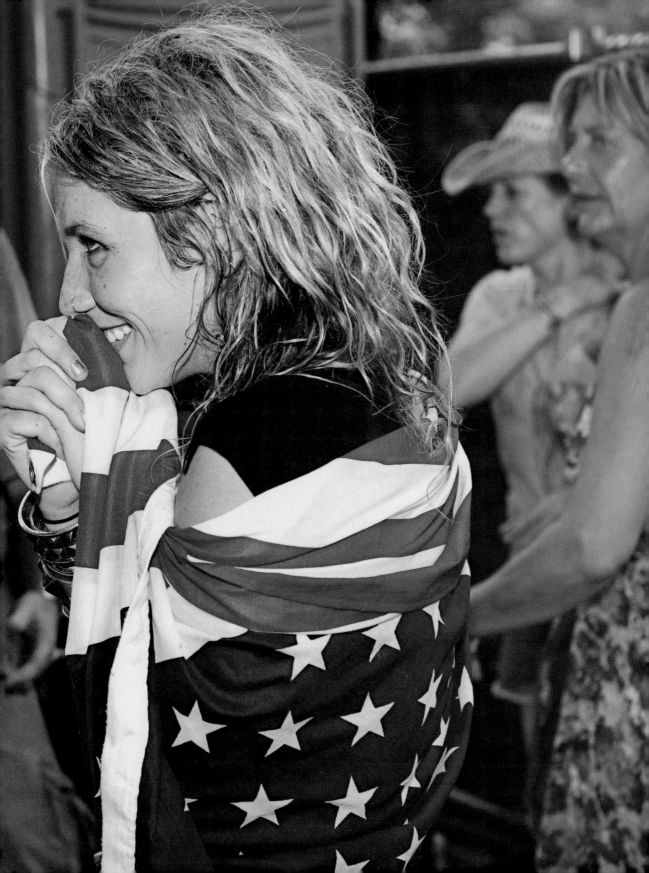

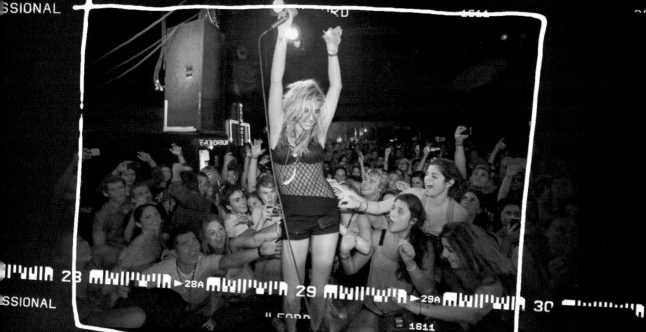

I play pop music, but when I started to develop my live show, I looked to rock and roll for inspiration. I love the energy, the subversion, the sex, and the sense of danger of rock and roll. I realized that I could play pop songs with a punk-rock attitude, and it worked. I admired the wildness and theatrics that people such as Iggy Pop and Alice Cooper brought to their stage performances.

Every song didn't have to be sung perfectly, but it needed to be sung and played passionately. During my first tour we played all the scummiest clubs across America, and I loved it. Seeing people lose their minds every night partying to my music was the greatest rush I had ever felt.

I wanted more.

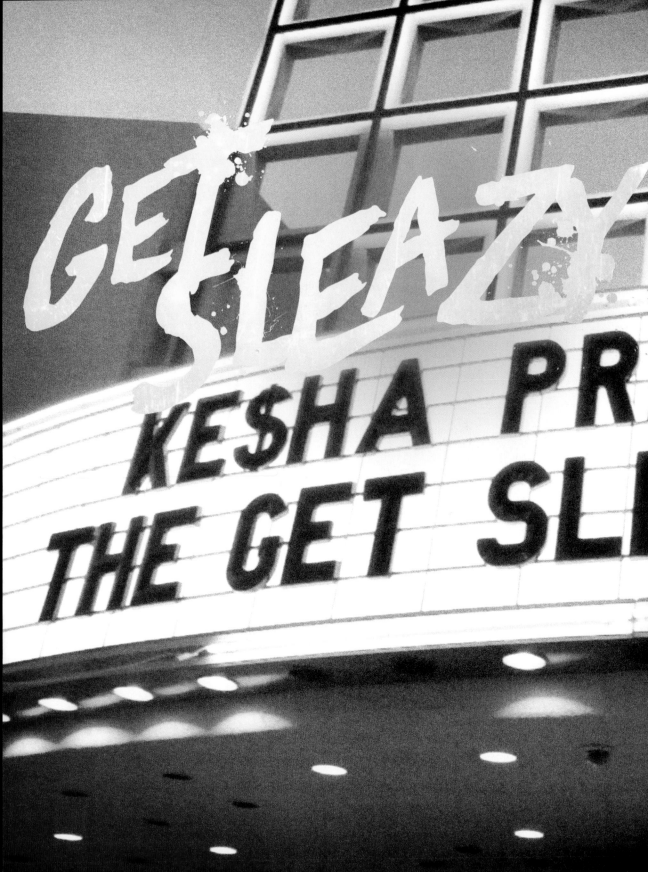

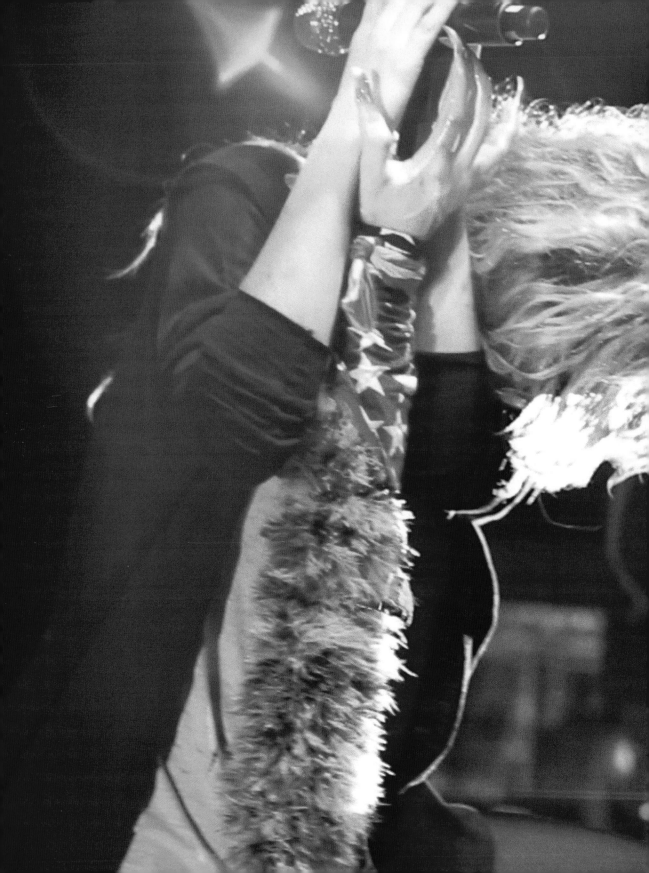

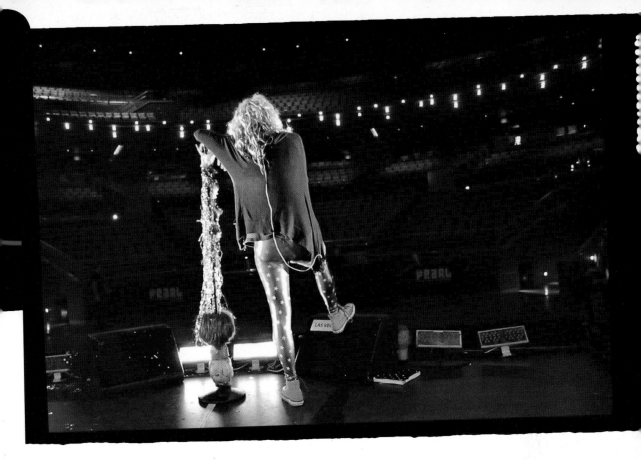

Standing on the stage staring out at an empty auditorium for the first time at the start of my first headlining tour, I felt an amazing sense of anxiety mixed with excitement. This time I knew that every night the crowd was there to see me . . . and I needed to deliver. I was about to do the biggest thing of my life. Everything I had been working for my whole life had led to this moment.

This tour was my chance to put my full creative vision on the stage. I designed every aspect of my show from the size of the glitter to the choreography, props, and lighting. It's a sensory assault, a graphic punk-rock odyssey set to infectiously catchy pop music. I wanted everyone to walk away feeling inspired, alive, and overwhelmed by the wild energy of my show. And I wanted everyone to walk away with glitter lodged in at least one orifice of their body.

I LOVE MAKING SOMETHING BEAUTIFUL OUT OF THINGS THAT OTHERS HAVE THROWN AWAY.

started making my own outfits when I was young. think it was the Gypsy in me that made me want to gather up discarded clothes and fabrics and sew it all into quirky outfits. It didn't win me many friends in school, but it helped out in the long run. design all of my stage outfits. My main influences for my stage outfits are pirates and seventies male rock stars like Keith Richards and Marc Bolan. I'm obsessed with rock Ts, ripped tights, short shorts, and boots.

And, of course, I love glitter. I'm not just saying that. I really really love glitter. I think everything should sparkle and shine. But it's also useful: when you have glitter on and you make out with someone, it stays on the person for days. It's like marking your territory. And if I get lost, you can just follow the trail of glitter to find me. Everyone on my tour has found glitter on questionable parts of his or her body. My assistant told me, "Sometimes think I have dandruff, but then I realize it's just glitter." My favorite place that I have found glitter is inside of an old band member's dreadlock, which we cut off and hung from a ceiling tile in Amsterdam on Thanksgiving.

My face paint changes from night to night. Sometimes I do it myself, and other times I have a makeup artist help me out, but I try to do something different for every show. Then right before I go onstage, I tease my hair to get it as big as a lion's mane. Then I'm ready.

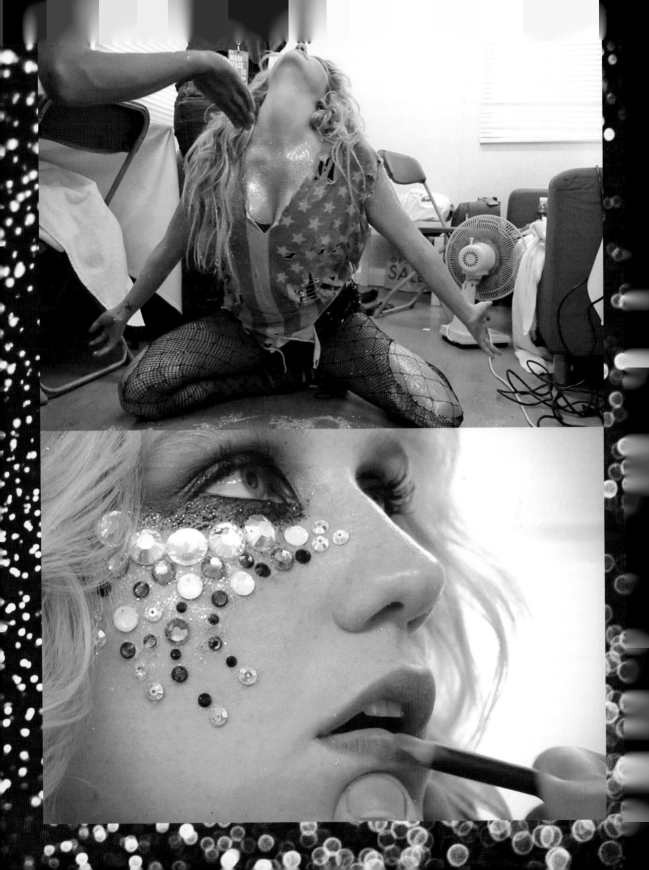

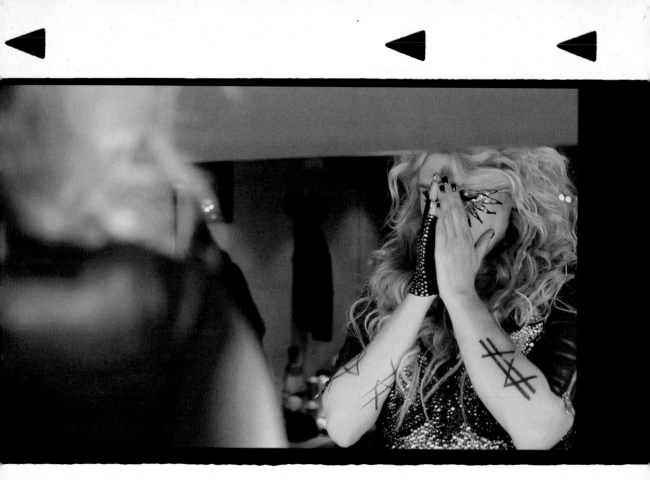

I always take a quiet moment right before every show. My live show is like my church: it means everything to me.

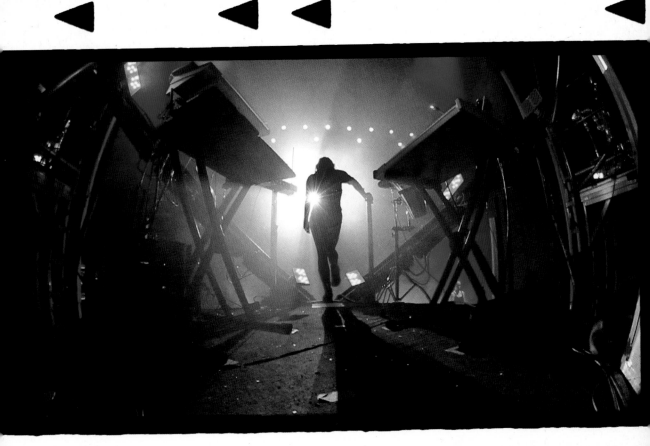

When I walk onstage and see my crowd covered in glitter with face paint, and ripped-up stockings, and massive hair, I know that we are in for a crazy night together. I feel that I'm the leader of a wild band of misfits on a mission to have the best time of our lives. The whole place goes nuts, and I can see people dancing, and making friends, and going mental. I want to give people a place where they can be 100 percent free.

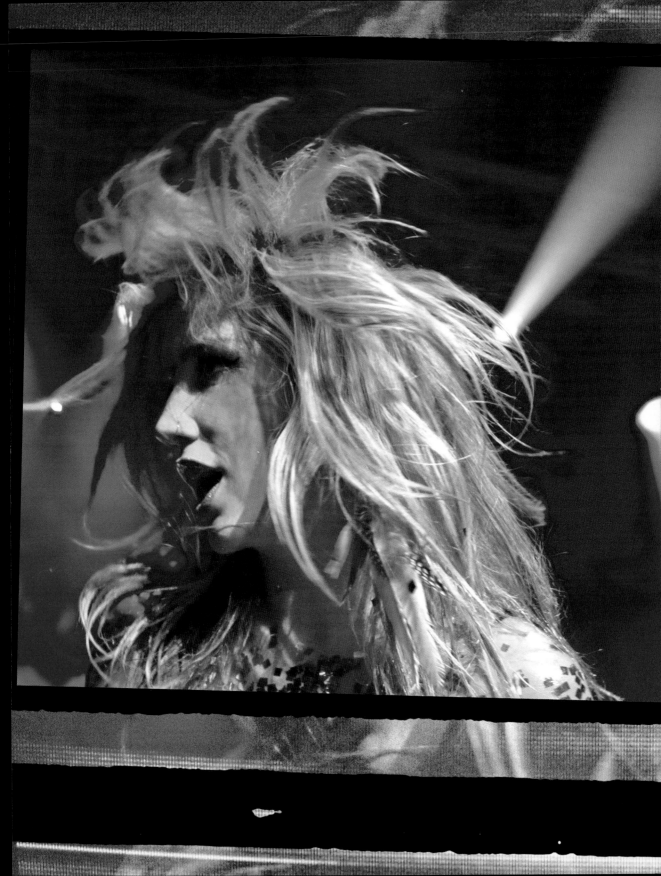

WHEN THE DARK
OF THE NIGHT
COMES AROUND.
THAT'S THE TIME,
THAT THE ANIMAL
COMES ALIVE.
LOOKING FOR
SOMETHING WILD.

IT'S TIME TO LOSE YOUR MIND
AND LET THE CRAZY OUT
TONIGHT WE'RE TAKING
NAMES CAUSE WE DON'T
MESS AROUND
THIS PLACE ABOUT TO BLOW

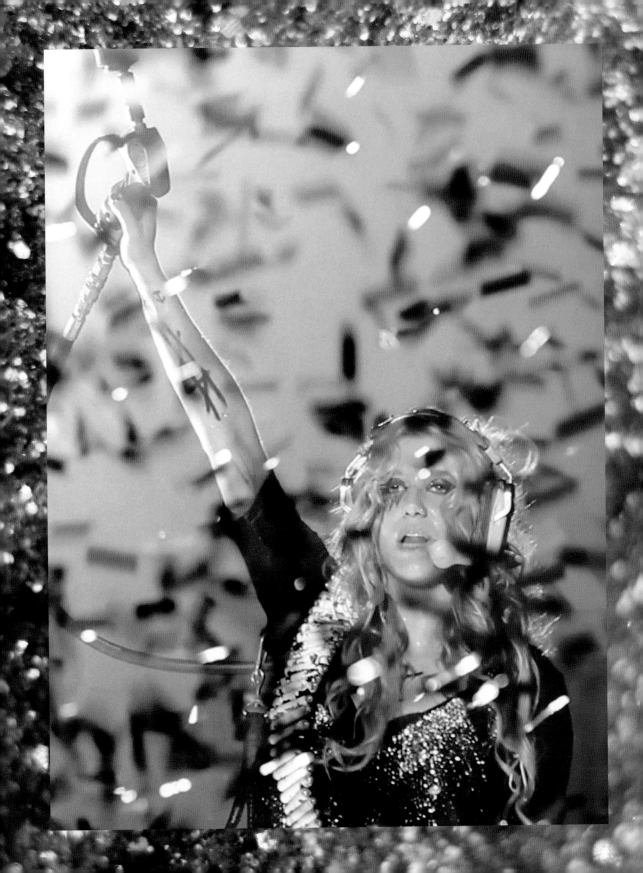

WAS IT GOOD?

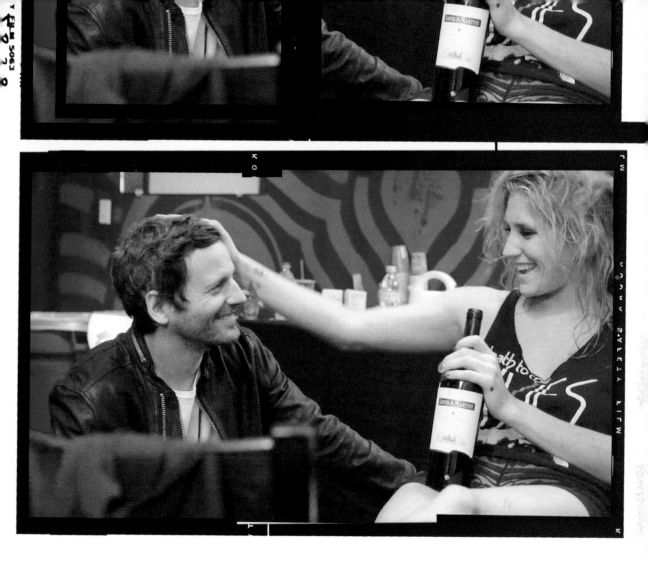

The first time that Dr. Luke saw my show on my Get Sleazy tour, he came to congratulate me in my dressing room. "Your voice sounded amazing. Your show was impressive and fun," he told me. "I'm so proud of you." Luke is a tough critic, so it meant a lot coming from him.

PARTY FOR A LIVING

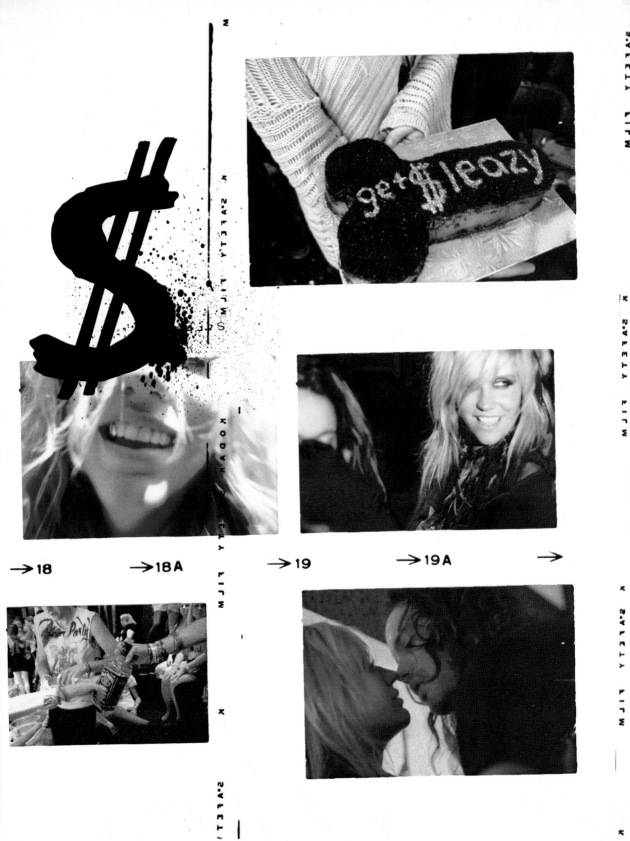

I've worked so hard to get to this point in my life, and I know that to keep it all going I have to take my work seriously. I embrace the pressure because I know how lucky I am, and I'm not going to let anyone take it away. It doesn't matter how hard I party, I always work ten times harder.

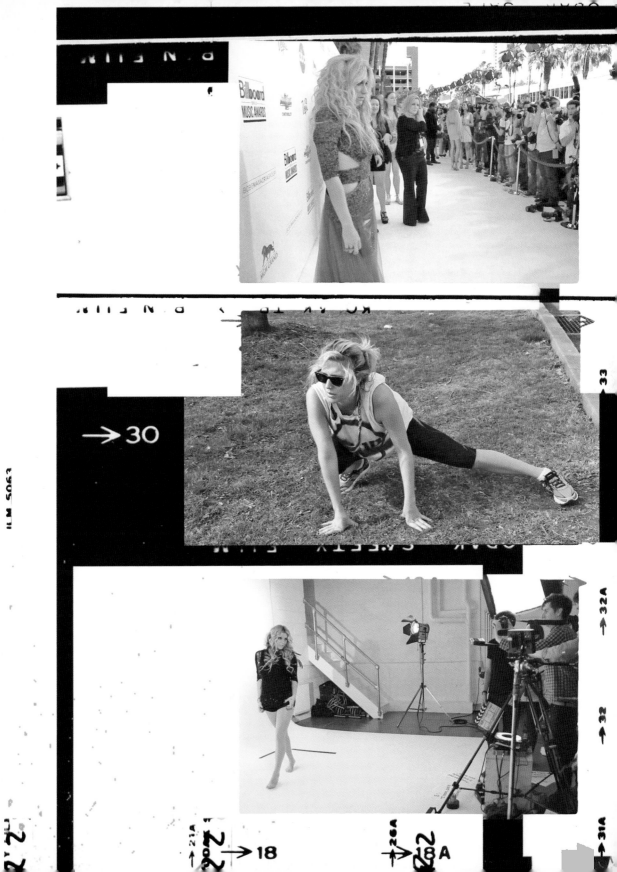

is this the ending
or are we gonna start again
is
the

end of time
dawn of time
58
8

champagne orless broke

158
us to the end of
time
8

8

My personal and professional lives have ceased to be separate. I've given up privacy and normality in exchange for my career, and I'm happy to have done it, but every once in a while I have a very human moment. But even when I get overwhelmed, I never forget how lucky I am. I know that this is the life I was destined to live. There is nothing that compares to life on the road. Seeing my fans makes everything worth it.

has come this I will tell

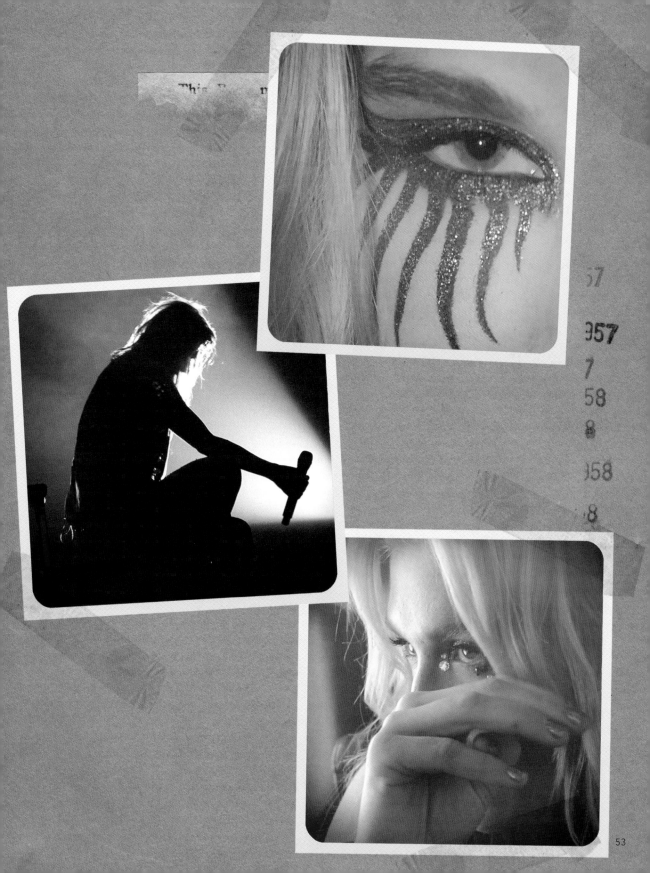

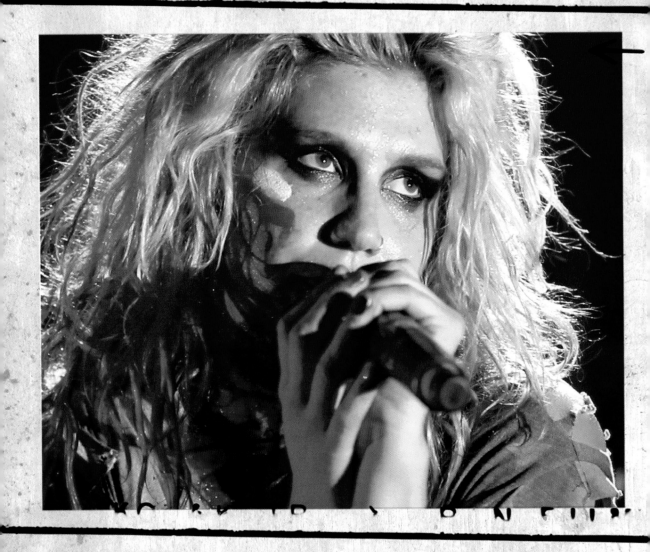

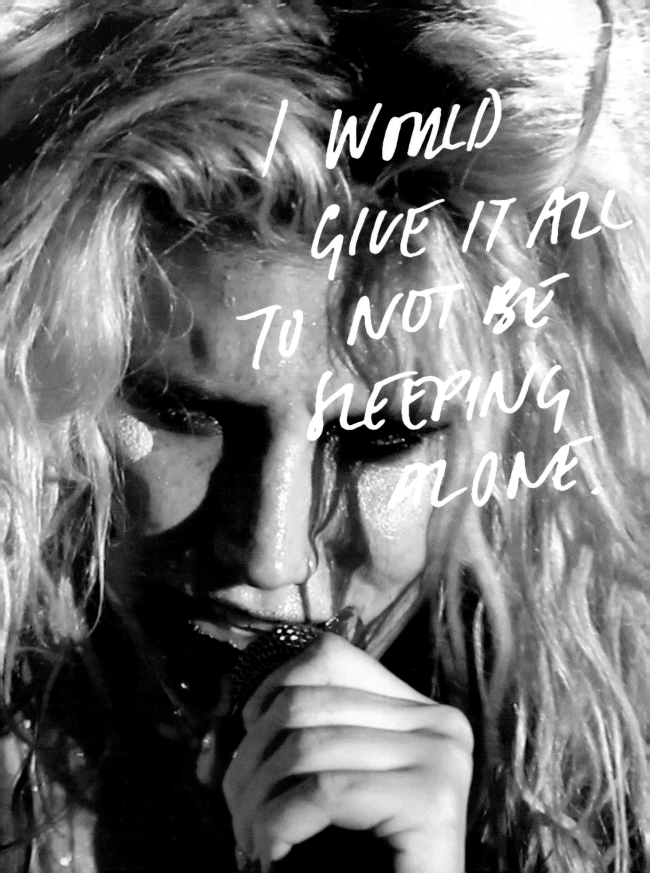

→ 30 → 30 A → 31

TIME WITH MY FAMILY HAS BECOME INCREASINGLY RARE AND SPECIAL.

→ 18 → 18 A

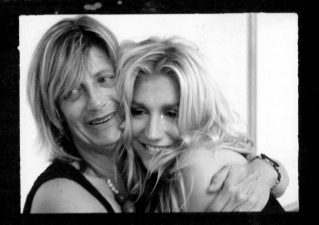

→ 19 → 19 A →

When I'm around them, they drive me nuts, but then when it's time for them to leave, I don't want them to go. It's my other family, my animals, that keep me going.

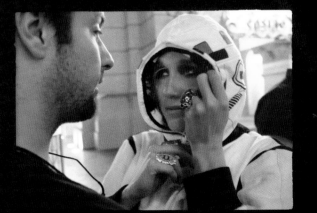

MY LIFE HAS CHANGED DRAMATICALLY BUT I WOULDN'T TRADE THIS CRAZY BEAUTIFUL LIFE FOR ANYTHING.

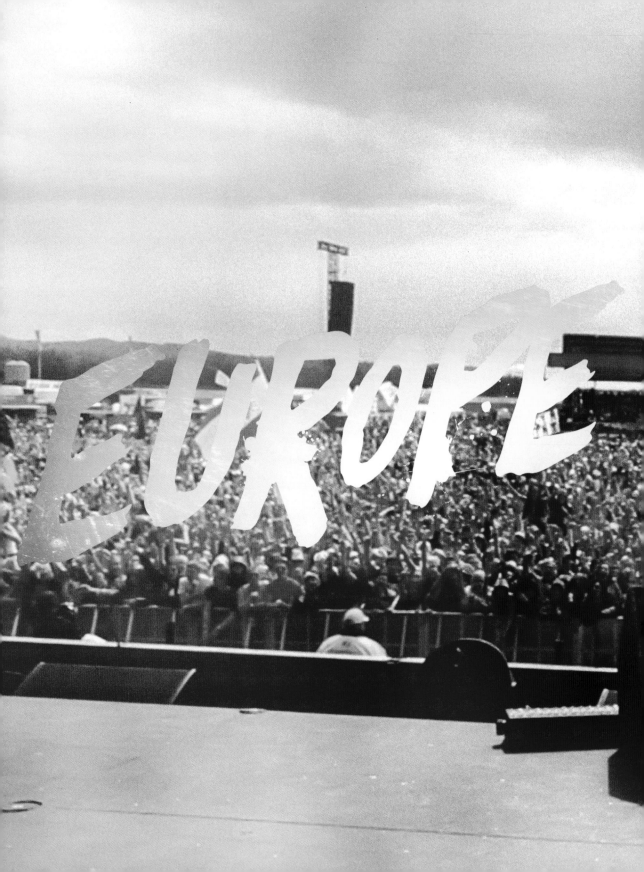

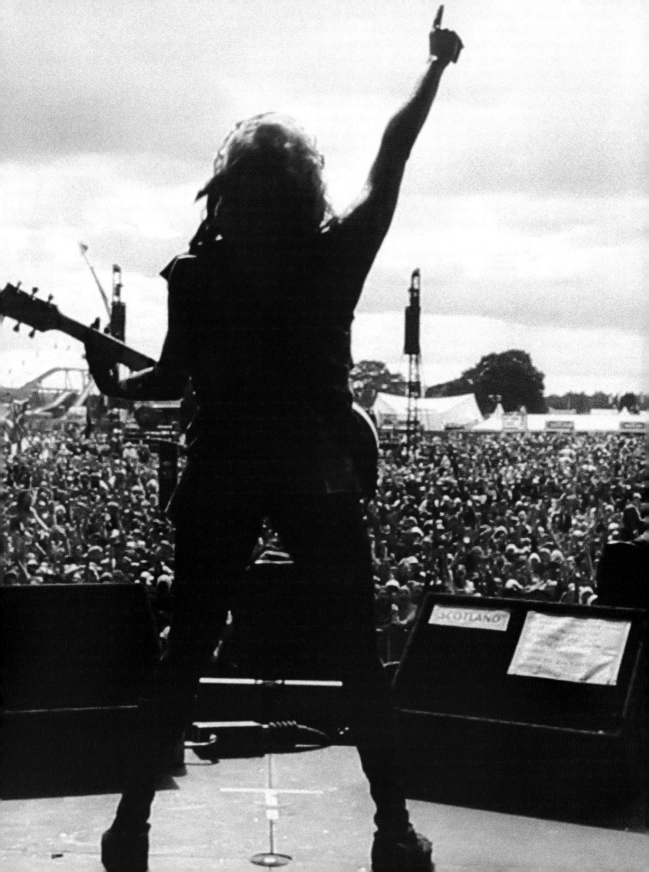

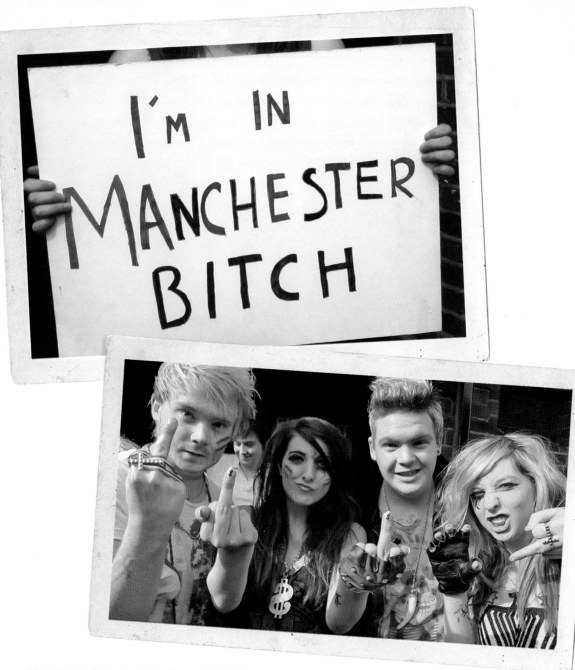

Manchester fans are crazy. They started lining up to get into my show about a day in advance. I left the venue to do a photo shoot for an MTV AIDS awareness campaign, and for a moment, as my fans were chasing the car down the cobblestone streets of the beautiful, old city, I felt like a unicorn. If only for a moment.

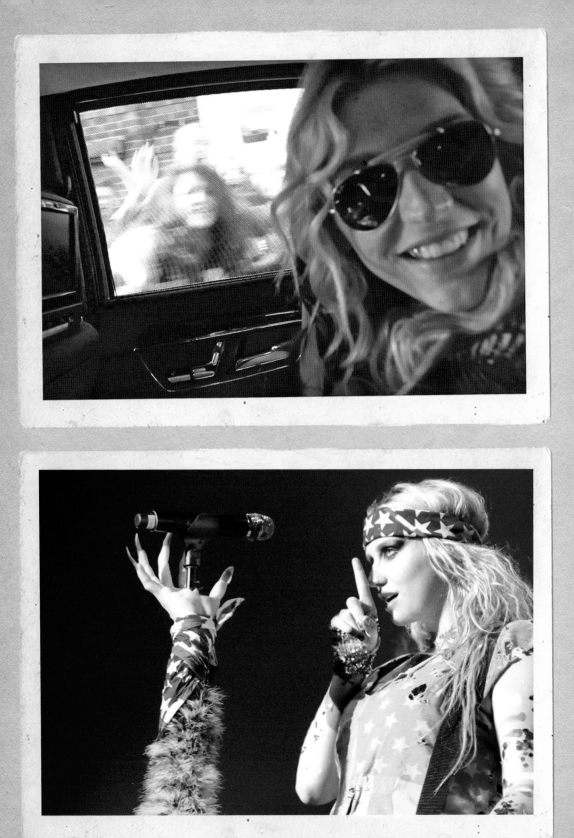

I've been dreaming of touring through Europe my whole life. Something about hopping from country to country daily is especially exciting, knowing that all of the greats have done the same thing.

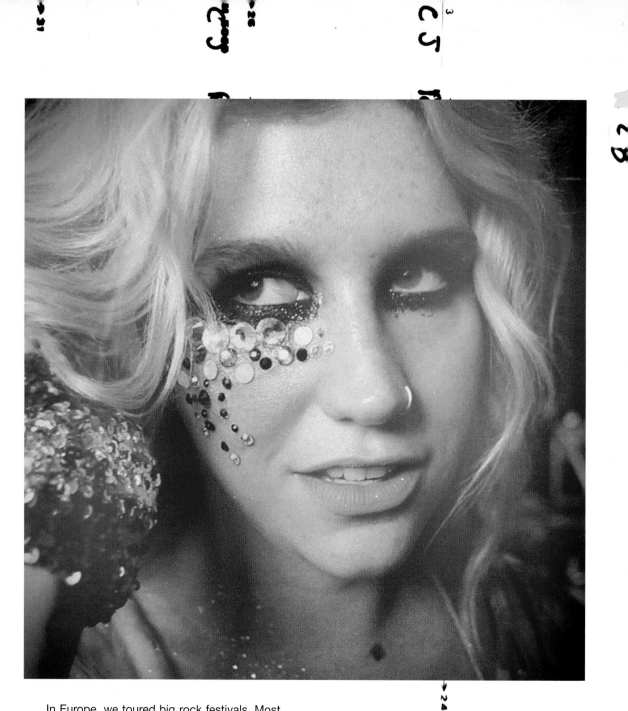

In Europe, we toured big rock festivals. Most of the people in the crowd didn't come to see a pop act, but my goal was to win them over by the end of my show, and I did.

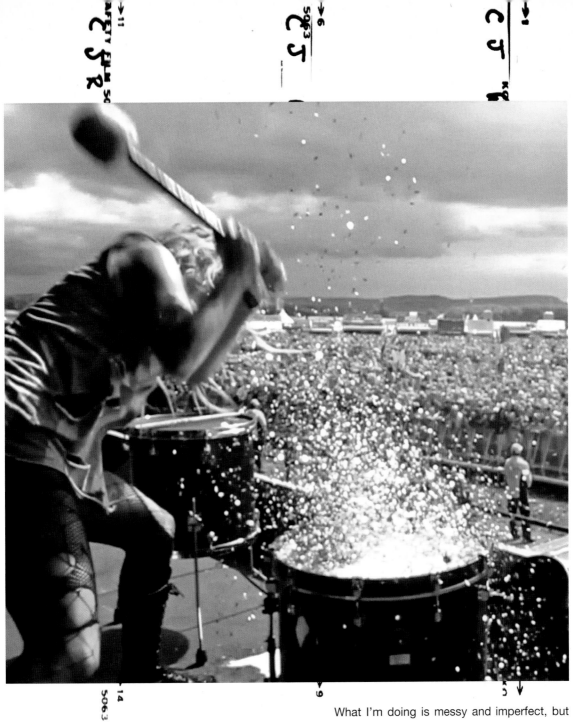

What I'm doing is messy and imperfect, but it's really fun . . . the energy is infectious. Everything is awesome when you are rowdy and sweaty and covered in glitter and beer.

MY ANCESTORS COME FROM HUNGARY, SO BEING ABLE TO PLAY A SHOW THERE WAS ONE OF THE MOST INCREDIBLE MOMENTS OF MY LIFE.

Legend is that my great-grandparents were Gypsies who owned a tavern in a small Hungarian town before they moved to the United States. There was music and dancing in the tavern every night, so I guess partying runs in my blood.

My mom traveled with me to visit the place where her parents were born. Walking through the streets of Budapest next to the Danube River and seeing my life-size picture on posters throughout the city made me feel like a proud warrior coming home.

I played in the central square of Budapest. I was the only performer on the bill, and it was the biggest show I had ever played. Seas of people blurred into the horizon. I couldn't see the end of the crowd. My mom wore the penis costume that I always carry around with me during the tour and danced around like a crazy person onstage when I played "Grow a Pear."

I couldn't believe that all of these people were gathered here for the sole purpose of watching me perform my music. That show made me realize more than any other show I had played that the words that I write can impact people all over the world. There is no telling how far the words I write will travel.

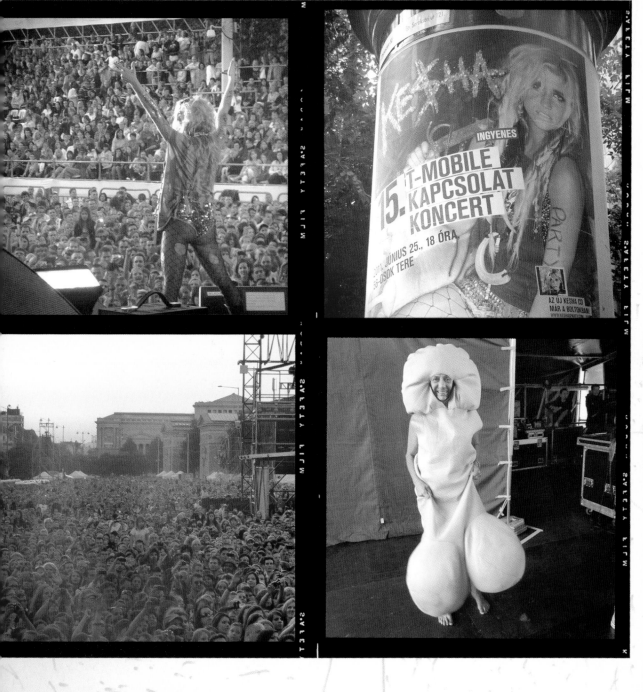

ALICE COOPER IS ONE OF MY IDOLS.

He didn't just write kick-ass rock and roll, he created a whole fantastic universe with snakes, guillotines, and gore. He inspired people's imaginations, and I want to follow in his footsteps.

Alice Cooper and I met backstage at the Grammys. I introduced myself and told him what a big fan I was, and later on he invited me into a studio to do a song with him. He asked me to play the devil on a song of his called "What Baby Wants." I felt proud when Alice worried that some of the lyrics I wrote for the song were almost *too* evil-sounding.

I LOVE ALICE COOPER...
AND HIS SNAKE.

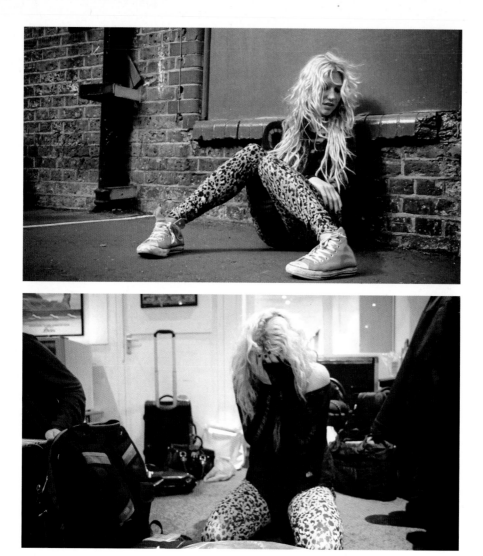

Touring in Europe was magical. Nearly every day we were in a new, fascinating country. My schedule was so packed that if I wanted to see a country or go out after a show, I barely had time to sleep. But sleep is not high on my list of priorities. On this tour, I didn't sleep for three days. On the third day, I was playing a show and I started hallucinating even though I was dead sober. Luckily, I know my set so well that I got through it.

It comes with the territory.

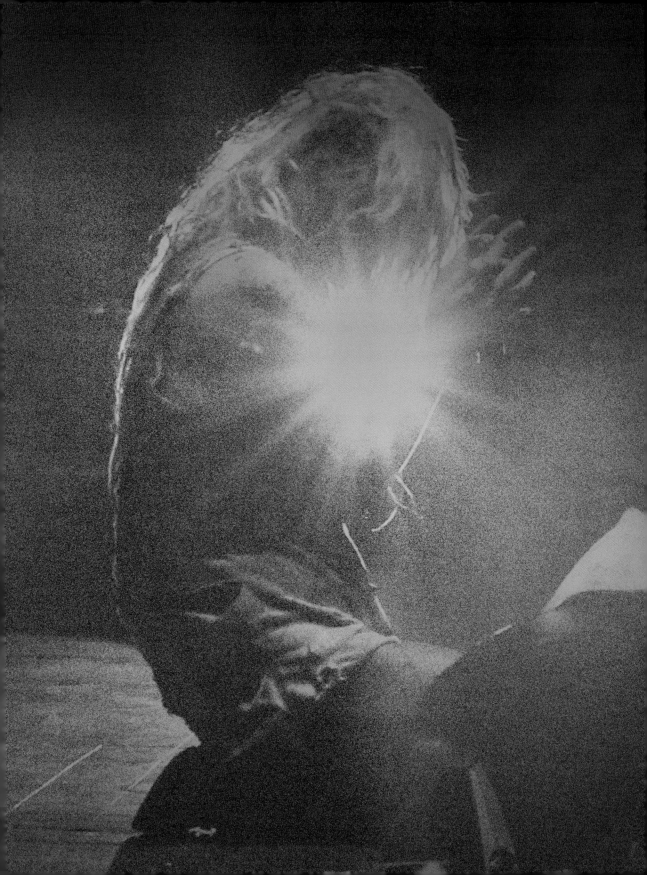

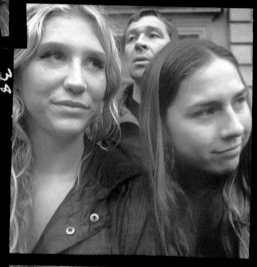

BUS BREAKS DOWN

Traveling in Europe, we were always on tight schedules. We were on our way to catch a ferry to the next show when our bus broke down. They tried to fix the bus while my best friend, Savannah, and I kept a lookout for beards. Europe has some pretty epic beards. They couldn't fix the bus in time, so we had to pile all the essential band and crew into one of our two buses and race on to the next festival. Sorry, Mom, you're not essential.

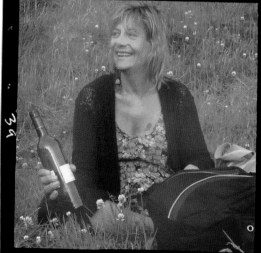

GETTING TO GLASTONBURY

Playing Glastonbury was such a big milestone for me. Glastonbury attracts hundreds of thousands of people from around the world, and I wanted my performance to be worthy of such a great festival. Tens of thousands of people covered in mud and face paint were running around partying. Glastonbury was my kind of place.

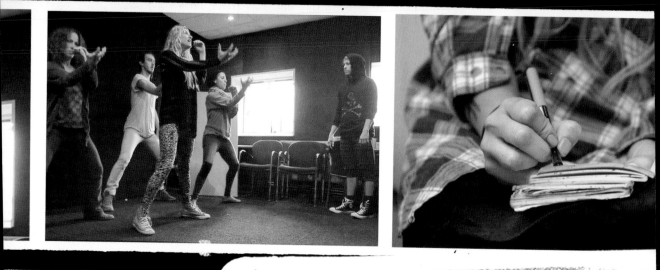

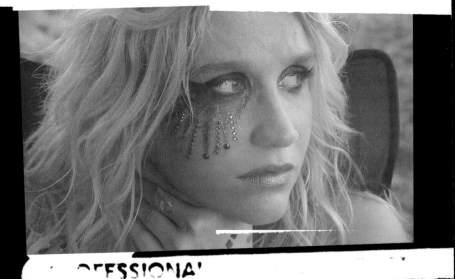

PROFESSIONAL

At the last minute, I was told that I had the opportunity to do a "surprise performance" the day before my scheduled slot. The surprise performance would be on a different stage, and we would be playing a shorter set. On the spot we had to reconfigure the whole show to fit the time slot and stage dimensions.

I had my tour manager use measuring tape to show me the dimensions of the stage so that

I could begin adapting the choreography with my dancers. Next, I sat down with my audio technician to find out how we could trim a few seconds off certain songs so that the show didn't run long. Trimming songs means adding new audio cues for the band and dancers, so we all had to go through the new routine.

By the time I took the stage for my surprise performance, it wasn't much of a surprise anymore.

The word had gotten out that I was playing, and the crowd was overflowing out of the dance tent. My adrenaline was pumping through the roof, and I sang my ass off. It was one of the most amazing shows of my life. I walked off the stage to a roaring crowd. Everything was perfect, but as I made my way back to my trailer, a rush of panic overcame me.

I had lost my voice.

I couldn't speak. At all. My throat felt as if I'd just swallowed a handful of razor blades.

I had to perform again in twenty-four hours on a bigger stage for an even bigger audience. I panicked at the thought of waking up the next day without my voice. I stopped talking and wrote all of my communications down to try to give my throat some time to heal.

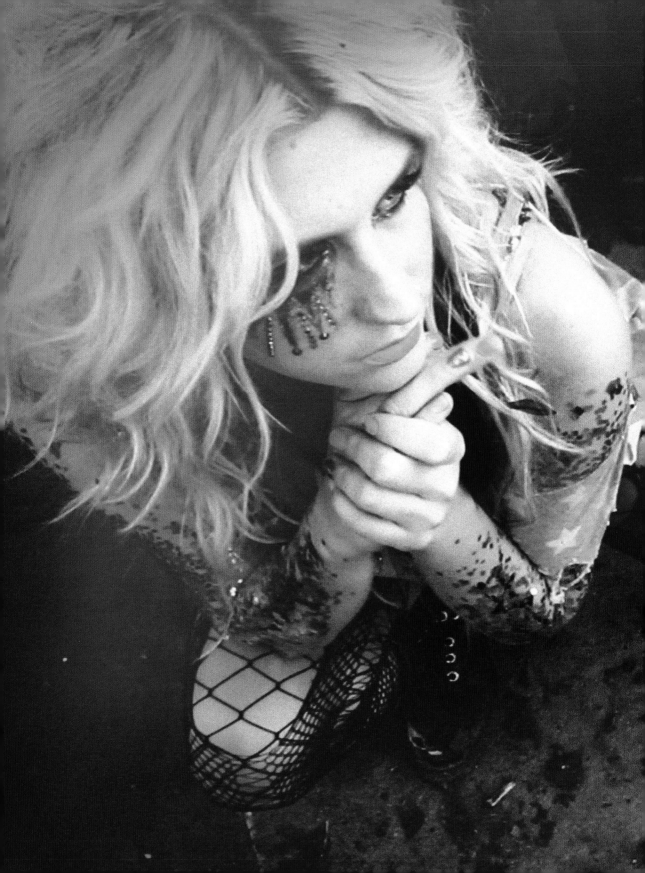

THE NEXT DAY I DIDN'T TALK AT ALL UNTIL SHOWTIME. I WASN'T 100 PERCENT SURE I WOULD BE ABLE TO SING UNTIL I TOOK THE STAGE.

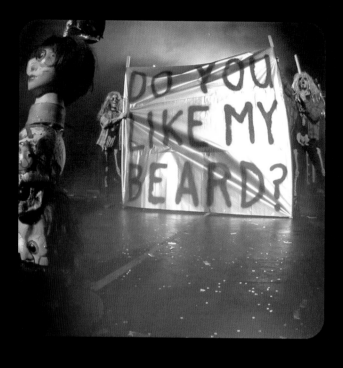

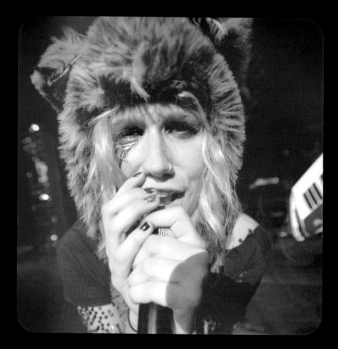

YOUR LOVE YOUR LOVE
YOUR LOVE IS MY DRUG
I DON'T CARE WHAT
PEOPLE SAY
THE RUSH IS WORTH
THE PRICE I PAY
I GET SO HIGH WHEN
YOU'RE WITH ME
BUT CRASH AND CRAVE
YOU WHEN YOU
LEAVE.

Almost every night I meet someone special who reaffirms my belief in what I am doing and makes every setback I have seem trivial. Many times I have been told that my music has helped someone get through hard times caused by bullying. I've been told my music speaks to people who don't feel that they fit in anywhere, which makes sense in part because I have always been something of an outcast myself. I am speaking from experience when I say just give the haters the finger and be true to yourself. You can't be a victim. You have to be a warrior.

I'm still a misfit and I will always stand up for people who feel that they don't fit in. I hope that my music and my shows motivate people to be themselves and speak freely, always.

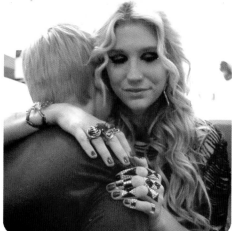

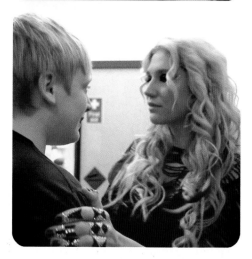

I AM IN LOVE WITH
WHAT WE ARE,
NOT WHAT WE
SHOULD BE.
AND I AM IN LOVE
WITH EVERY PART
OF THIS WHOLE
STORY.

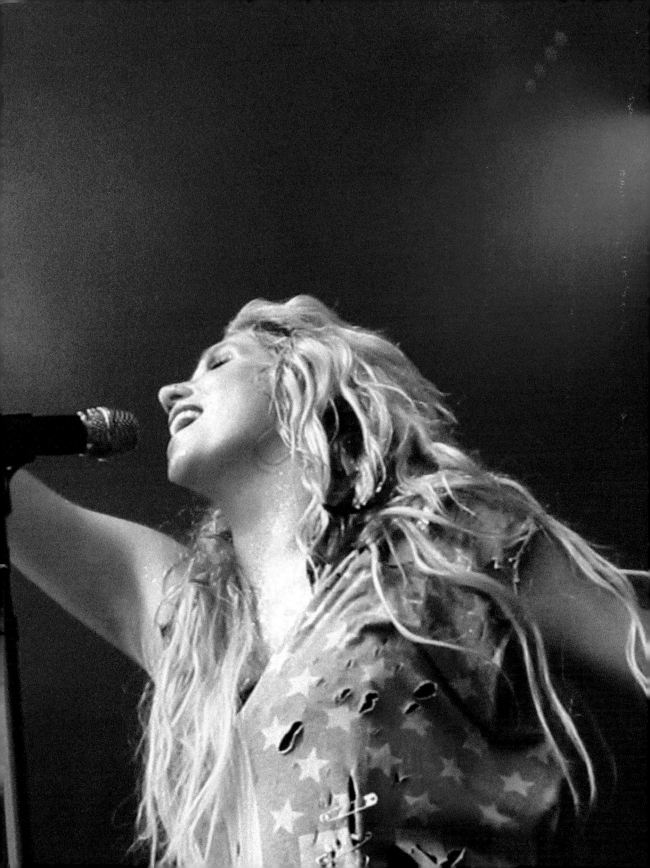

I'd been on tour almost nonstop for nearly two years, but rather than being exhausted, I felt that I was on a roll. I leave it all on the stage every night, and now we were playing bigger and bigger venues to more and more people. We extended the Get Sleazy tour because the first leg sold out in minutes.

ꟿꟿⅡᒋᵞⅡꟿ 28 ꟿꟿⅡᒋᵞⅡꟿ ▶28A

1611

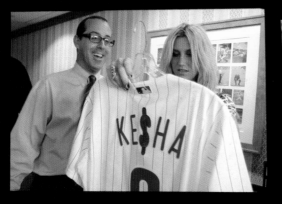

ꟿꟿⅡᒋᵞⅡꟿ 29 ꟿꟿⅡᒋᵞⅡꟿ ▶29A

ꟿꟿⅡᒋᵞⅡꟿ 25 ꟿꟿⅡᒋᵞⅡꟿ ▶25A

It's great to be back in the USA. I always appreciate America even more after being away for a while. The American flag is such an important symbol for me because it stands for freedom. I practice my right to freedom of speech and freedom of expression every day. But this sense of personal independence isn't the only thing that I love about my country. Here are a few of my favorite things that remind me of America and start with the letter *b:* boys, baseball, baseball players, boots, butts, blood, boobs, and, of course, beards.

KEEP THAT SCRUFF LOOKIN' ROUGH GIVE ME BOOTS & BOYS.

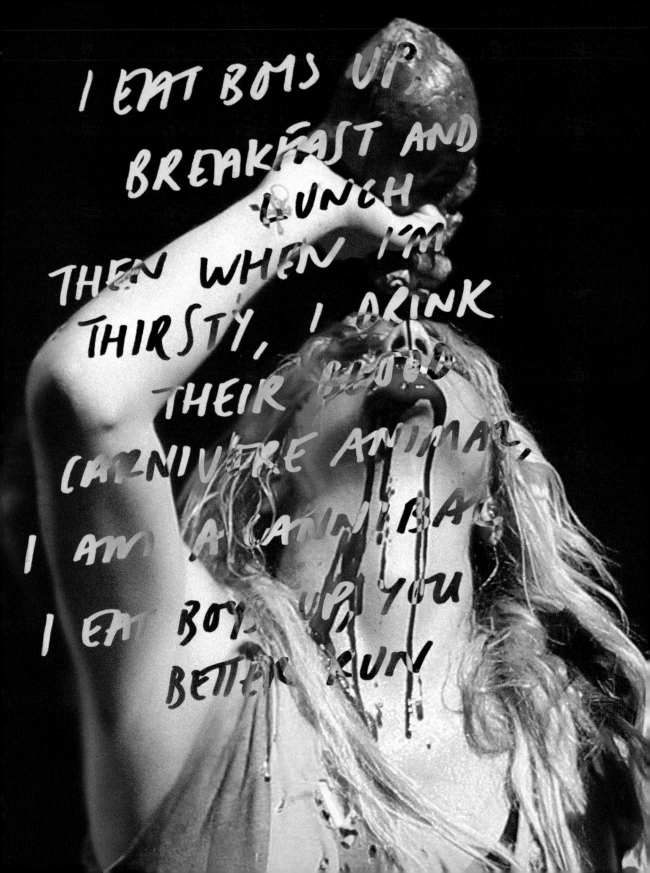

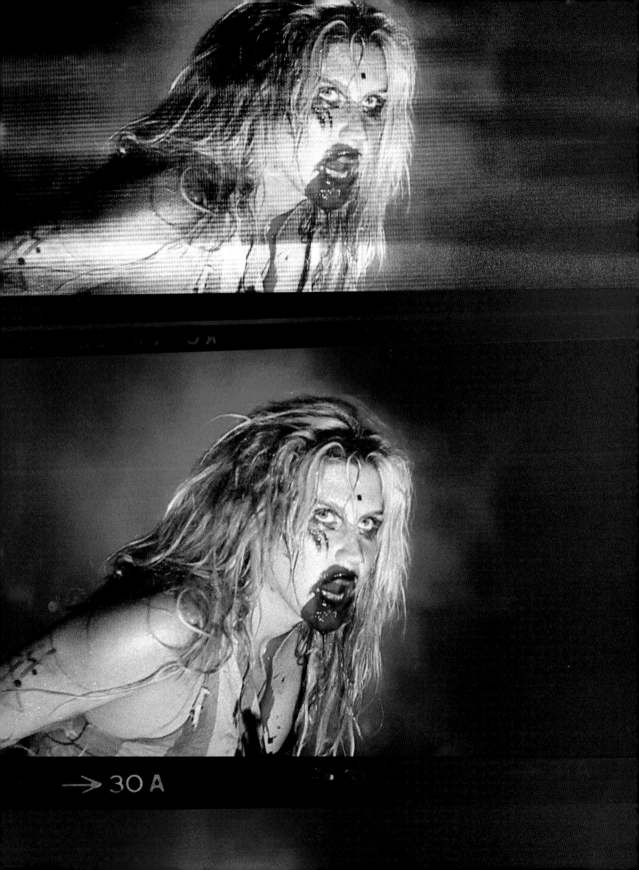

→ 30 A

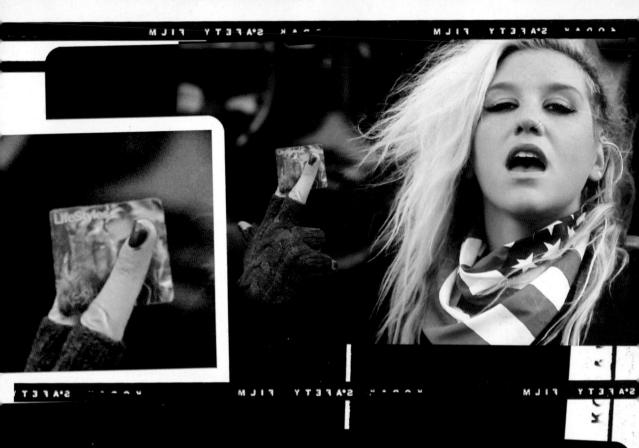

I've seen pictures of my face in a lot of places in the last few years, but possibly my favorite is on these extra-special Ke$ha Condoms. Be safe when you are doing it . . . and think of me!

I'm about the least patient person I know. I don't like sitting still. Ever. So my tour makeup artist and I played a little game called Keep Ke$ha from Getting Bored During Glam. He always lost. Then I would be forced to find other ways to entertain myself by, say, breaking the chair, giving somone a prison tattoo, or, better yet, playing one of my other favorite tour games, called Let's Torture Max!

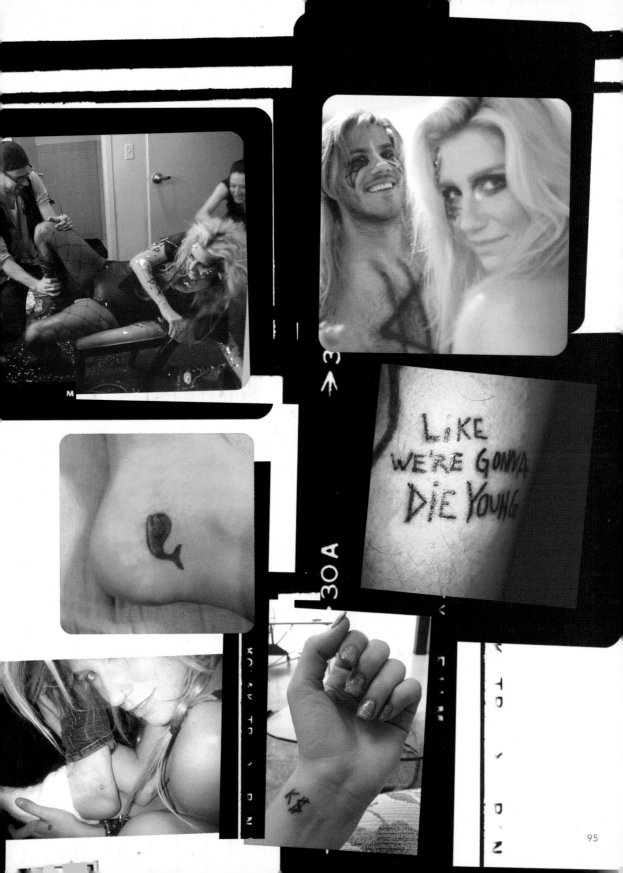

LiKE
WE'RE GONNA
DiE YOUNG

95

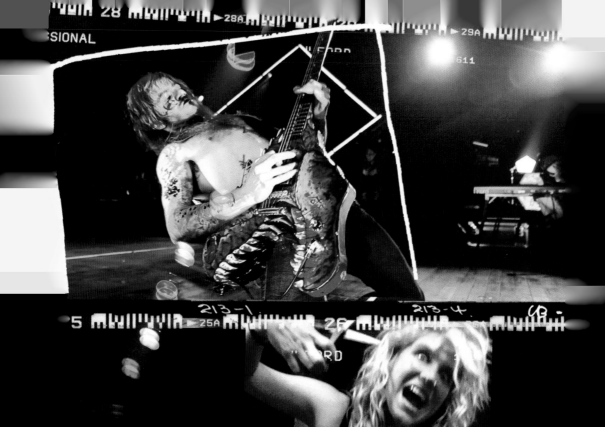

the only member of my original band
at has been with me the entire time. He
round because I'm such a good boss.
when I'm feeling extra generous, such
when we were all driving back from a
y at 4:00 a.m., I offered to give him a

was wasted except for Max, and I
ke sure that he was having a good

had a pair of scissors in my fanny
im a nice mullet right there in the
driving back to the hotel after

Alice Cooper had joined us onstage. This
we lovingly refer to as the Alice Cooper M
Doesn't he look happy! I give Max free hai
all the time. He loves it! Another time, I gave
a free tattoo ten minutes before we had t
onstage. I'm the best boss ever.

On tour, I spent so much time with my
and crew that they became like a second fa
Max probably knows me as well as any
besides my brother. He helps keep the rest o
band in line, and is a much-appreciated voi
reason on tour. Oh, yeah, and he shreds on g
and rocks out hard.

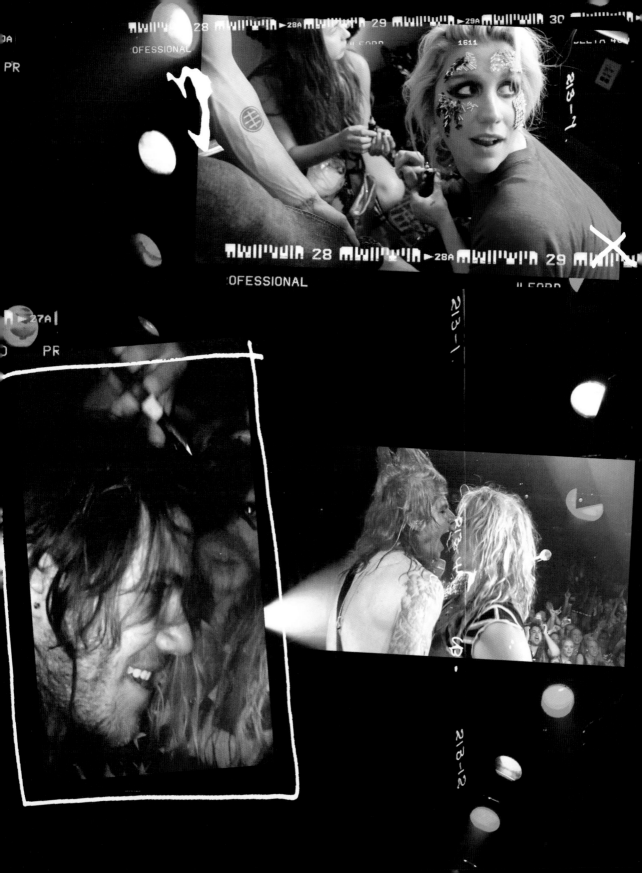

COME ON

X Swimming pool, limousine,
come on let's do it
come on let's cause a scene,
come on let's do it
cigar in the caviar, come on
let's do it
I'm pissing in the Dom Pérignon,
come on let's do it now
Now, come on let's do it

LET'S DO IT

I'M IN LOVE WITH MY CRAZY BEATUIFUL LIFE

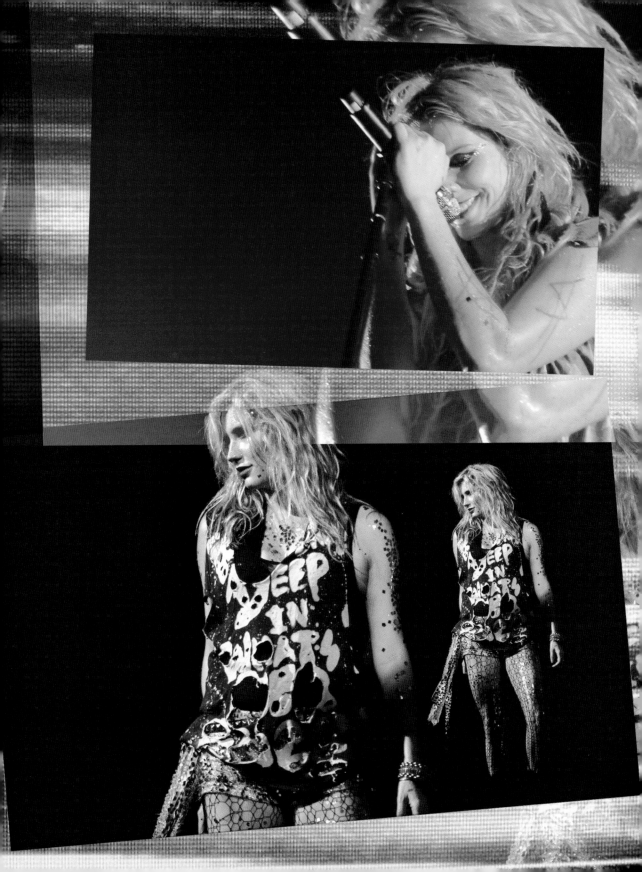

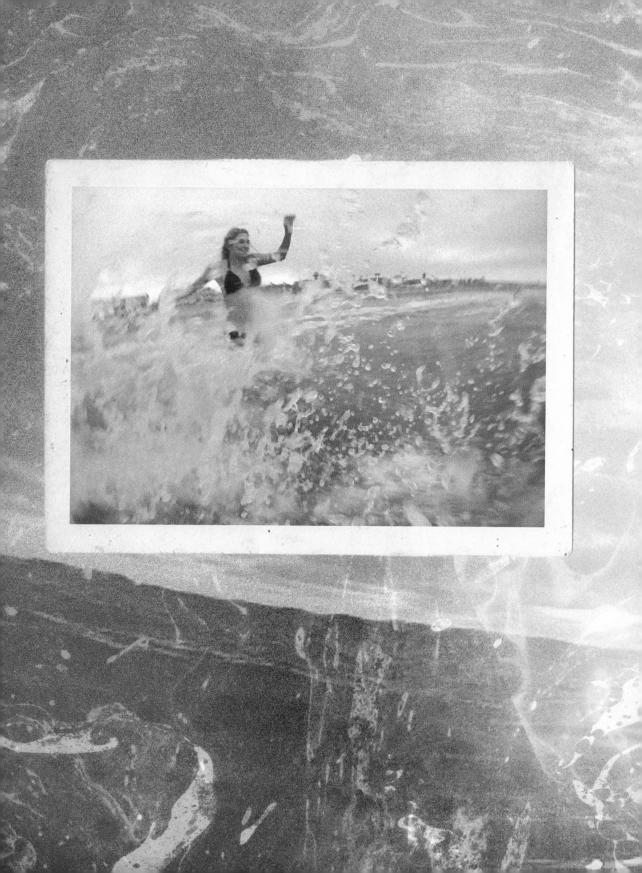

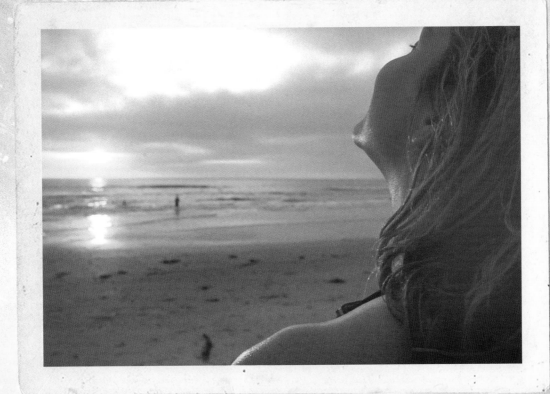

Coming back to the West Coast and selling out huge amphitheaters makes me see that I have realized my dreams. It's scary when your dreams come true because all dreams end, and I don't want this dream to ever end. It's up to me to keep it all going.

We played the last US show on the Get Sleazy tour in Phoenix, Arizona. I took everyone out to dinner the night before. As we gathered in one dining room, it dawned on me that even though we were going out there night after night and putting on a huge pop show, only a small group of people had helped me put it together. My show had come a long way, and though it may look like a big-budget production, it came together in DIY style, and it took every single person to pull it off.

The last US show was bittersweet for so many reasons. I was ready to move on to the next stage of my career, but I was sad to leave the people whom I had spent so much time with and who had become close friends. I was especially sad to leave a nice, young, bearded man who became known on tour as Baby Spoon. He was my tour boyfriend, and when the tour ended, I felt like a girl leaving camp, sad to say good-bye to her summer crush. At the last US show, my band spray painted BABY SPOON in the hallway of the venue, and when I saw it, I almost peed myself from laughing so hard. After the show, we got the whole rowdy crew together in a bar and did what we do best one more time.

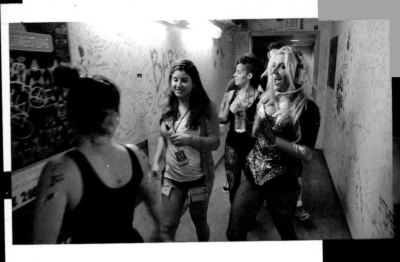

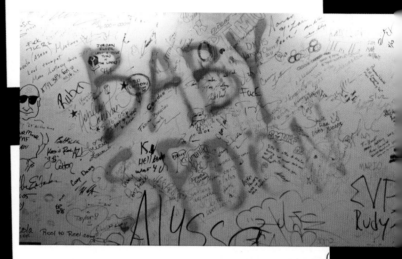

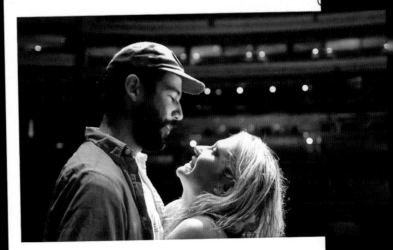

MY SLEAZY ROAD FAMILY.
I'M SAD ABOUT IT!
ONY, ELIAS, BOOT, PAT. ASIAN STEVE, JACK, JAMES,
ESSA, RAY, LOGAN, BRIANNA, MAX, JEN, AUSTIN,
SLYN, STEVEN, EMILY, MONICA, SAVANNAH,
CHIEF, NICOLE, CHRIS, ERIC, LAYAN, CADAVER.

Thanks

THE LIST

JACK (OUR FEARLESS LEADER) = GANDALF

RAY = FRODO BAGGINS

TESSA = ICEMAN

ERIC = SKY FOX

ANSON = KNIGHT RIDER

BRENT = FALCON

TONY = PRIME MINISTER

CHRIS = THE DUDE

BRIAN = RED FOX

SHANNON = GINGERly

POD = BIZKIT

CHIEF = CHIEF

PAT = DONNIE

BOOT = BOOT

ASIAN STEVE = YELLOW ROSE

BUTTERSCOTCH PUDDING = OF COURSE YOU KNOW WHO..

END TRANSMISSION = SHIT!

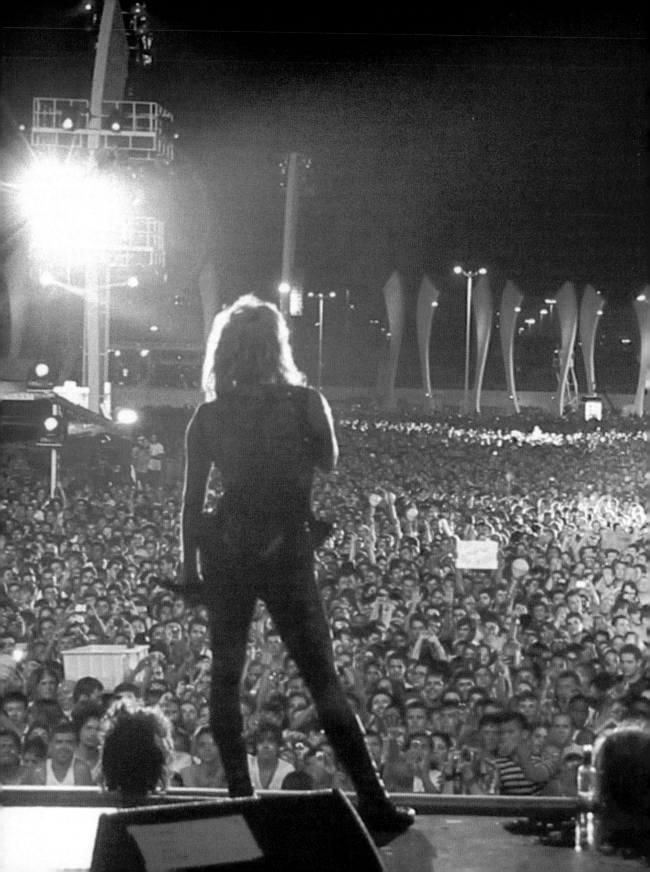

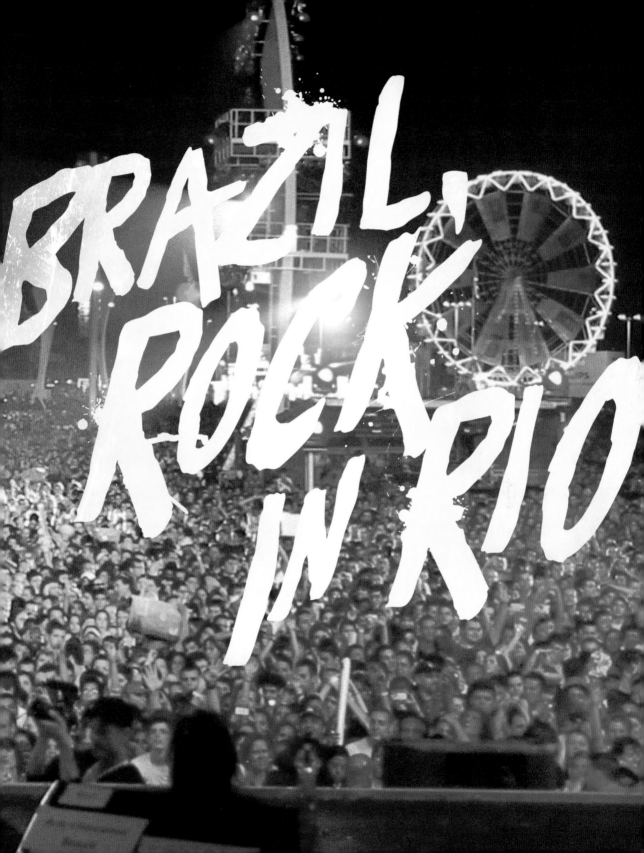

I ARRIVED IN RIO DE JANEIRO AND THE AIRPORT WAS SWARMING WITH PAPARAZZI.

I'd been traveling for twenty-four hours and I hadn't slept or showered, so the last thing I wanted was my photo taken and broadcast around the world.

As I got off the plane, we saw all the photographers running around and ducked into a corner to devise a plan. "What am I going to do?" I asked my brother. "Just blend in and sneak past them," my brother suggested. That sounded way too boring an option to even be considered.

"Wait a second, isn't it destiny that I've been carrying around a stuffed shark all day?" I said. Then it hit me—I'd just tie the stuffed shark onto my head to create a diversion.

"Except maybe you should tie the shark in front of your face rather than just on top of your head, like a crazy-person hat," suggested my brother. Okay, fine.

But how were we going to stabilize the shark on my face? We tried the strap from a camera bag, but that didn't work so well. I know . . . "Steven take off your shoelaces," I ordered.

Yes, perfect! No one will notice me now!

But as soon as I started making my way from the terminal to where our transportation was supposed to pick us up, a crowd of people started gathering around, pointing and laughing. People acted as if they had never seen someone running through an airport with a stuffed hammerhead shark tied to her face before. Jeez!!!

Of course the paparazzi were on us in no time. And guess what? No one knew where our transportation was. So now I am just standing there with a stuffed hammerhead shark tied to my face and about a dozen photographers swarming around me while we are trying to hail a taxi. Eventually, we got a cab and my hammerhead shark and I made it safely out of the airport.

Moments such as this make me realize how much my life has changed. It's still crazy to me that paparazzi want pictures of me hailing a taxi.

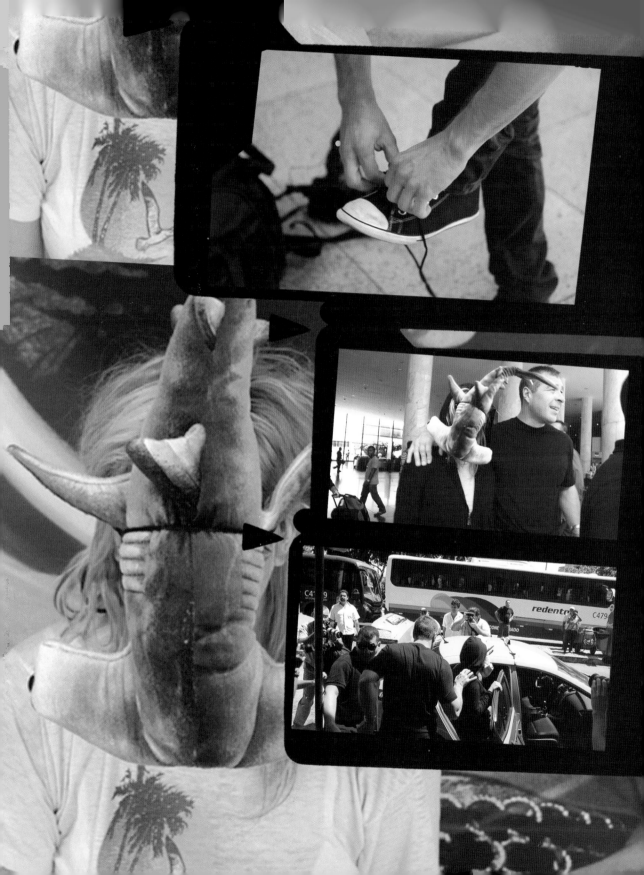

After I got to Rio, the first thing I wanted to do was go hang gliding off the famous cliffs that stick up thousands of feet from the beach and dominate the landscape. Playing huge concerts has turned me into something of an adrenaline junkie.

I never felt naturally comfortable onstage. I had to work to conquer my stage fright. Now that I know that I can overcome my fears, I try to do anything that scares me. That's why I love trying new things like skydiving or hang gliding. If anything scares me I force myself to do it to prove that I can.

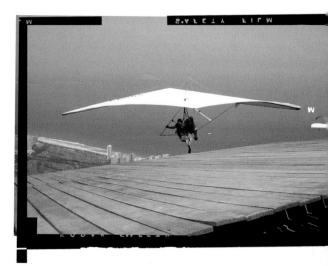

Jumping out of an airplane is not all that different from getting onstage in front of tens of thousands of people. Or performing on live TV. You just have to take the leap of faith and commit yourself 100 percent. As long as I'm still alive when it's over . . . I'm happy.

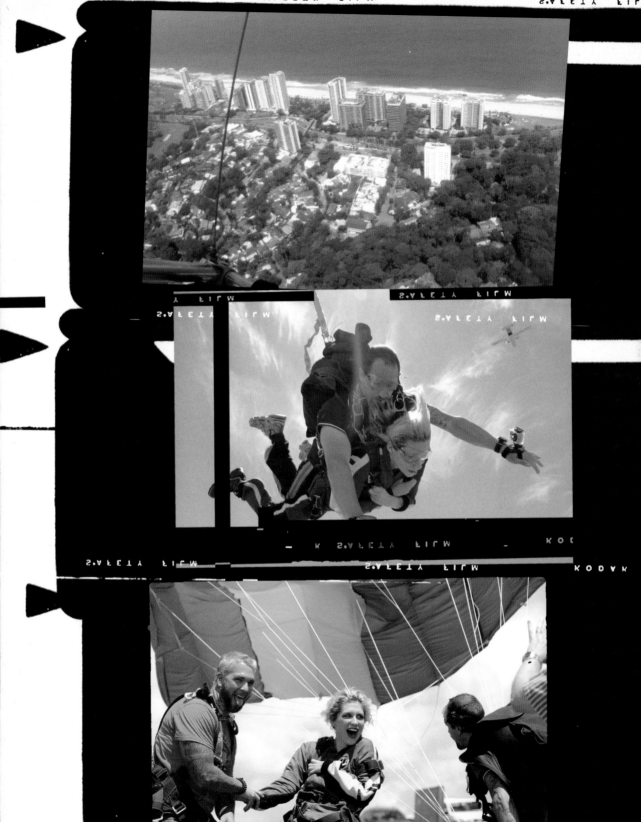

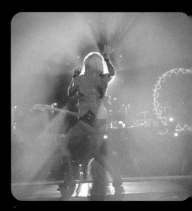

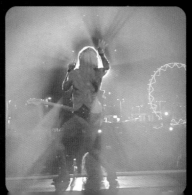

YOU KNOW
WE'RE SUPERSTARS.
WE ARE
WHO WE ARE.

I'M IN LOVE WITH YOU, BRAZIL.

During the show I looked out at the crowd reaching back to the towering cliffs of Rio de Janeiro and heard thousands of people who don't even speak the same language as me sing words that I wrote back to me louder than my own voice. I saw Stevie Wonder's band on the side of the stage getting ready to follow my performance, and I felt so moved by the experience that I had to say something to the crowd:

"This is my first time in Brazil. And this is one of the most incredible nights of my life so far. It's very humbling to be sharing the stage with Stevie Wonder tonight. This is my last show for my Get Sleazy world tour, and I have to thank you from the bottom of my heart for coming out tonight. I've been dreaming of playing in Rio since I was young. I never dreamed it would be on the main stage of Rock in Rio."

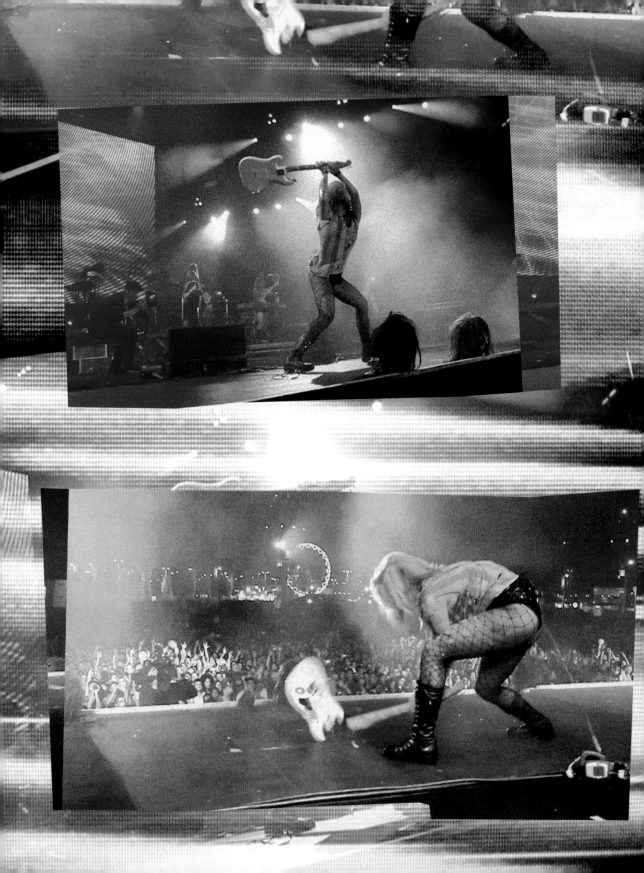

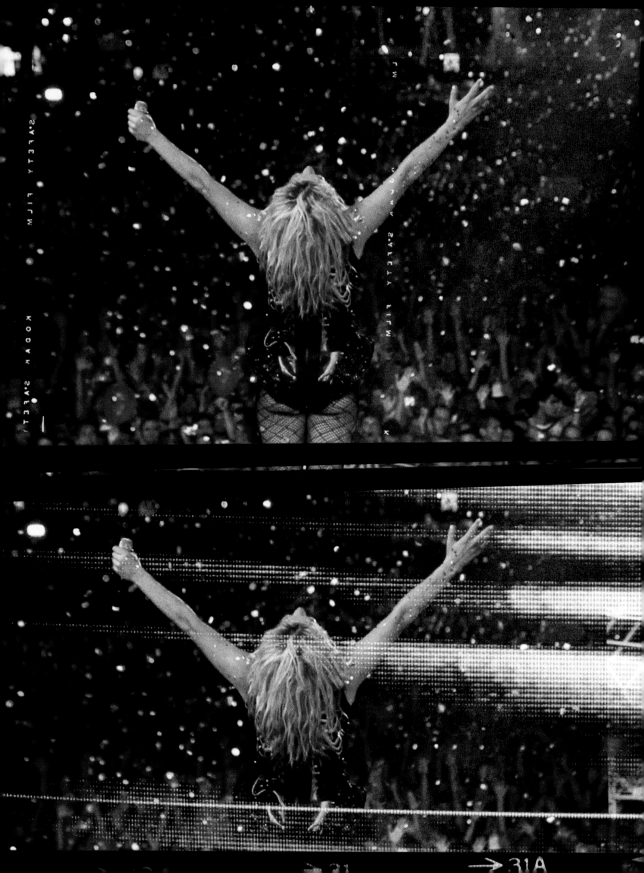

WOOOOOOOOOOO!!!

THIS IS HOW A FOOD FIGHT GETS STARTED.

After the show, one of my dancers made the mistake of dumping a salad bowl on me. I ran back to the dressing room and grabbed a handful of raw vegetables. "Come here, you little dancer! I've got something for you," I said as I crept around the corner. I yelled, *"Cauliflower!"* as I hurled a raw piece of it as hard as I could in my dancer's direction. But those dancers are quick. He ducked and the cauliflower went straight into the eye of one of the managers of another band.

Sorry about it!

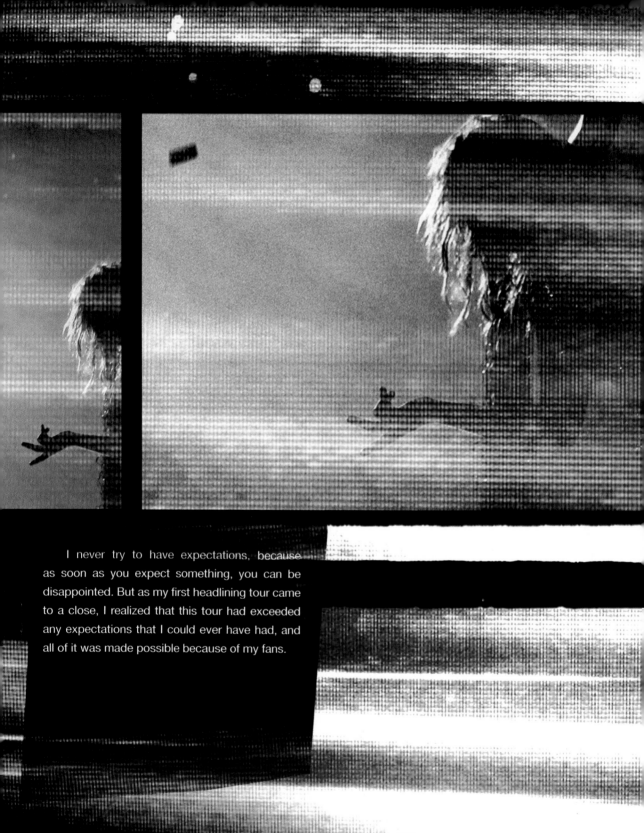

I never try to have expectations, because as soon as you expect something, you can be disappointed. But as my first headlining tour came to a close, I realized that this tour had exceeded any expectations that I could ever have had, and all of it was made possible because of my fans.

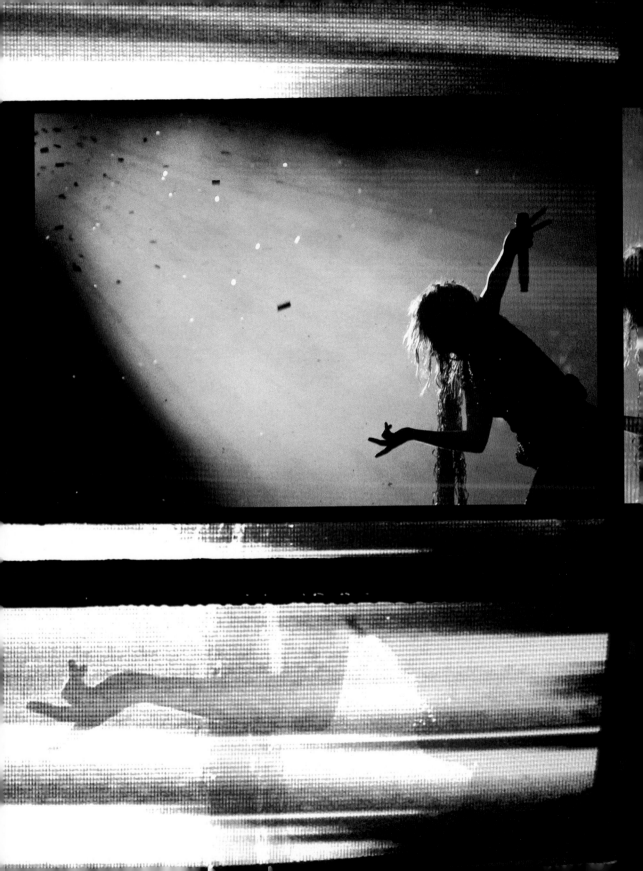

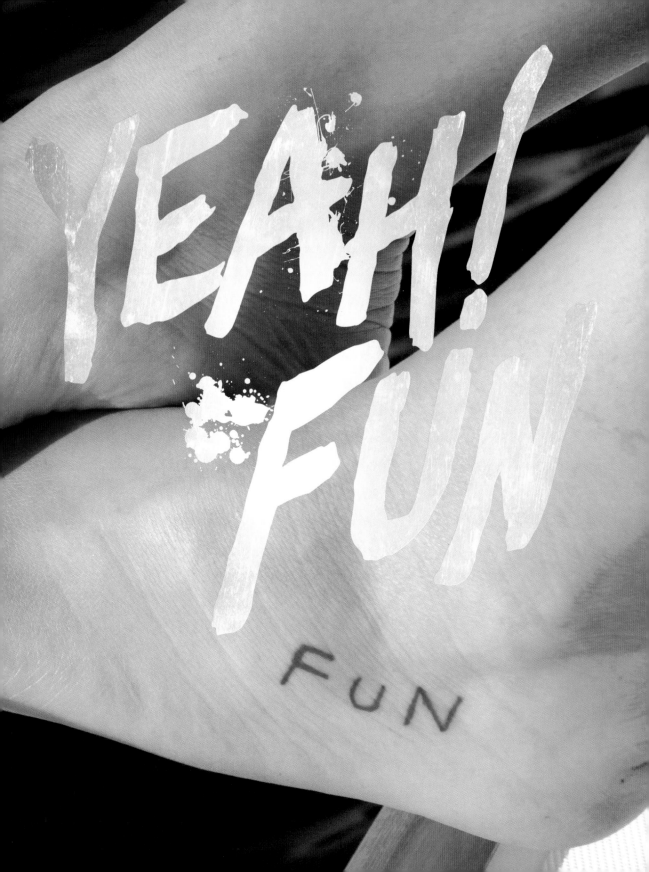

The morning after I played Rock in Rio, I hopped on a plane to the Galápagos. My managers wanted me to bring security personnel, but all I wanted to bring was a backpack. It was liberating to venture off with nothing tying me down except for the weight on my own back.

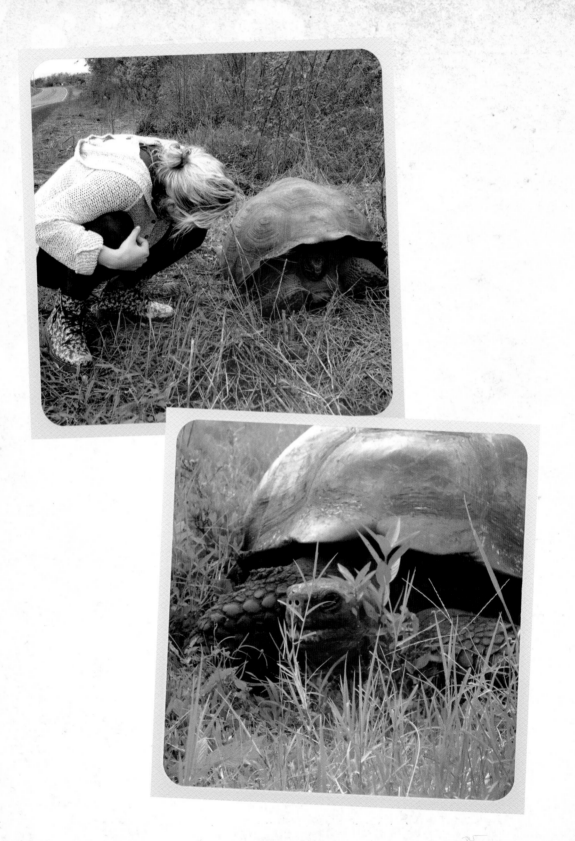

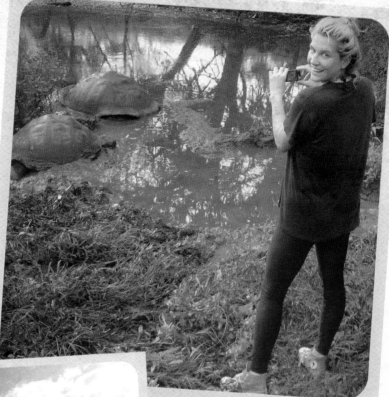

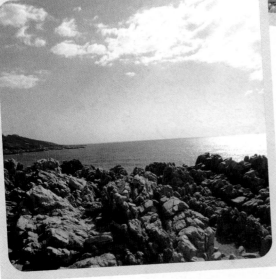

Ever since I was young, I wanted to visit the Galápagos because I was fascinated by the natural history of the place. I spent a lot of time scuba diving and hiking. One day, I trekked for hours to a secret beach where I found giant tortoises. The tortoises live for well over one hundred years and are the same type of tortoises that Darwin based much of his research on.

The Galápagos seemed like a place trapped in prehistoric time, and y'all know I love that shit.

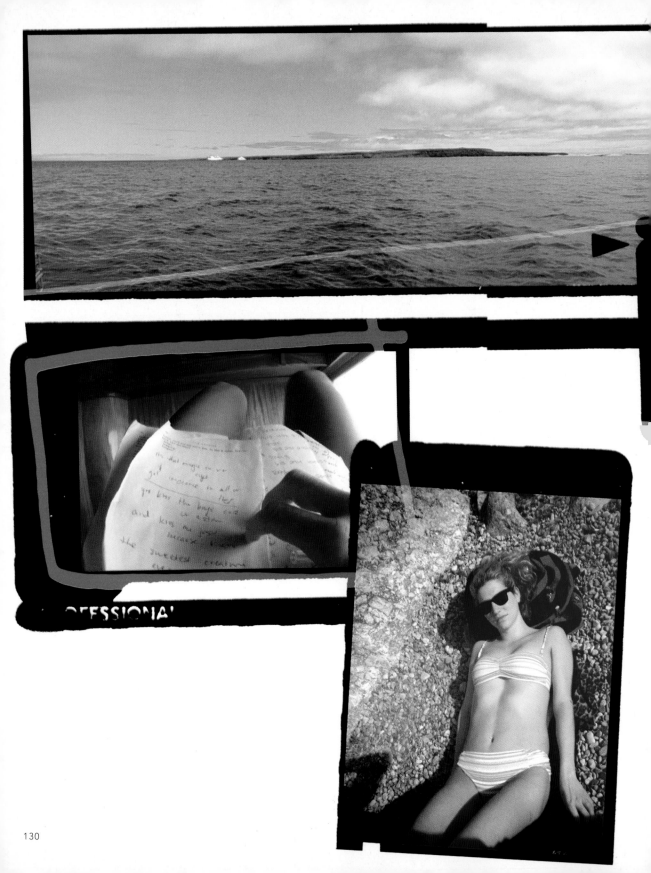

Though it was the first real vacation I had taken in years, the beauty of the place was so inspiring that I immediately started working on songs for my next album. Being in the the Galápagos reminded me what a wonderfully weird place the world is. So much magic is everywhere, but sometimes it gets obscured by modern life.

I was scared about the challenge of writing my next album, and I knew that I would face enor-mous pressure to re-create the success of my first album. Sitting alone on one of the prehistoric rocks looking out on the endless ocean, I vowed to not let the pressure paralyze me. I knew that I had it in me to make an album that not only lived up to my own expectations but could also get the whole world dancing.

In the Galápagos, I decided that the title of my next album would be *Warrior.*

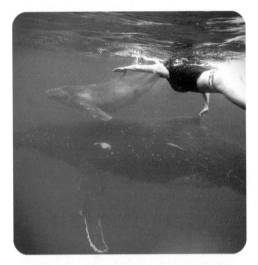

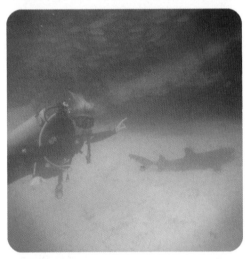

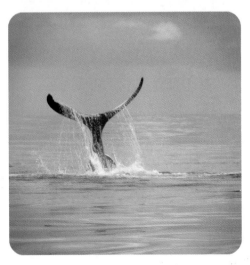

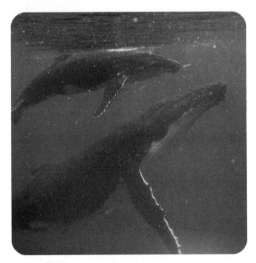

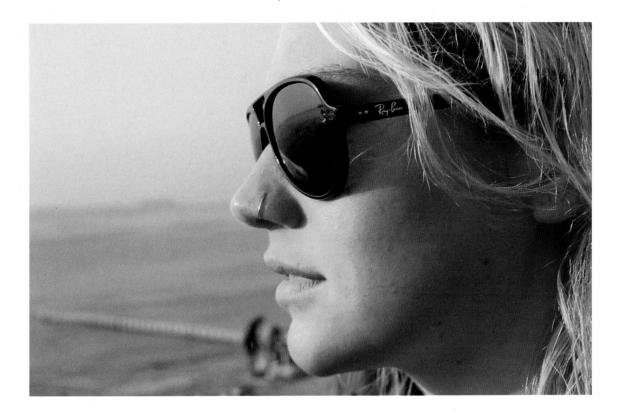

From the Galápagos, I traveled to the middle of nowhere to dive with whales. I slept on a friend's boat and anchored it at a completely deserted island and tanned nekked with no worries of paparazzi.

Every day I went scuba diving. Having a humpback whale sing to me was one of the most amazing experiences of my life. These beautiful creatures are even more amazing when you are within arm's reach. I could feel their energy, as I swam next to them.

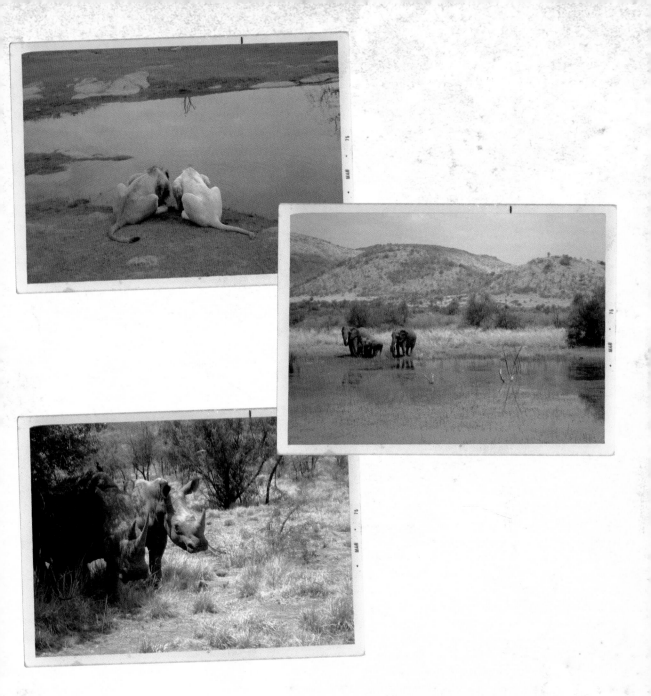

After swimming with whales, I traveled to South Africa to continue my spirit journey to bring myself closer to the natural world. Getting to see so many wild animals living free in their natural habitat left me fully refreshed and ready to write my record.

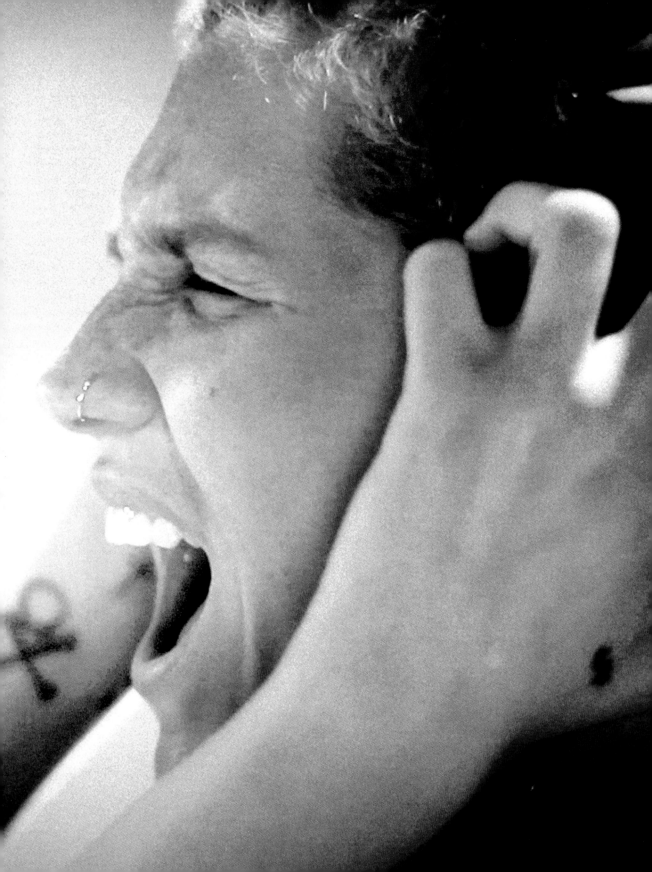

I had worked so hard to get to this point in my life and had had the most incredible few years. But writing for my sophomore album, I knew that despite everything I've done, if I didn't write an incredible album, my career could fade away. I had to make sure the new songs were amazing. I couldn't just try to re-create my first album because I wasn't the same person that I was when I wrote it. I still liked to party, but now I had so much more to write about.

Writing *Warrior,* I was only certain about two things: the attitude of the music would be influenced by seventies rock icons such as the Rolling Stones, T. Rex, and Iggy Pop, and the message behind the music would be positive. Beyond that, I was open to experimentation. I wanted to make music that I would be excited to play every night. This was my biggest challenge yet. I needed to write a record that would live up to my fans' expectations and my own.

WRITING MUSIC IS MY FAVORITE THING EVER.

When I write a good song, I get the same euphoric feeling as when I'm falling in love—except when I'm writing, that feeling is not dependent on anyone else. Writing for me is like a drug. I start writing and my fingers get clammy and I feel a rush of energy and my heart starts racing, because it's so exciting. I'm lucky to have so many incredible fans, and it's a gift to realize that the music that I write could be listened to by millions of people around the world. It makes the whole process even more meaningful.

As I started writing *Warrior*, what kept coming out of me was positive stuff about how people should try to love one another and not to judge one another. I know I'm not the first person to sing about that, but it was where my mind was going at the time, and I don't think it can be said too many times.

One of the first songs that I wrote for *Warrior* is called "Love into the Light." I started writing it while I was traveling on vacation, and when I finally got home, I sat down at my piano and wrote the song by myself.

140

I KNOW I'M NOT PERFECT
I KNOW I GOT ISSUES
I KNOW THAT I'VE GOT A SORDID PAST
AND YES SOME BAD TATTOOS
I'M NOT A MODEL. I'M NOT A SAINT
I'M SORRY, BUT I AM JUST NOT SORRY,
CAUSE I SWEAR AND CAUSE I DRINK,
BUT MAYBE IT'S ABOUT THE TIME
TO LET ALL OF THE LOVE BACK IN THE LIGHT
MAYBE IT'S ABOUT THE PERFECT PLACE
TO LET GO AND FORGET ABOUT THE HATE
LOVE INTO THE LIGHT
I KNOW WE'RE ALL DIFFERENT
BABY THAT'S LIFE
BUT OF ALL OF THESE DIFFERENCES
THEY MAKE ME FEEL ALIVE
AND I'VE GOT THIS QUESTION, YEAH
BEEN BURNING THROUGH MY HEAD
CAN'T WE ALL GET OVER OURSELVES
AND JUST STOP TALKING SHIT
MAYBE IT'S ABOUT THE TIME
TO LET ALL OF THE LOVE BACK IN THE LIGHT.
MAYBE IT'S ABOUT THE PERFECT PLACE
TO LET GO AND FORGET ABOUT THE HATE
LOVE INTO THE LIGHT

all get over ourselves

just stop t

ourselves

stop talking

shit

C, D, F, G

CD, A G

CD F G

I know that I've got a
I'm trying to love my sor
pa

know I aind perfect
know I got issues
know that some a ya
e my gold tooth & bad tattoos
m not a model
not a saint

One of the most amazing experiences I had recording *Warrior* was getting to work with Iggy Pop on a song called "Dirty Love." Iggy Pop is one of my idols and an absolute legend.

I wrote "Dirty Love" with my mom and Matt Squire. The song was inspired by some of Iggy Pop's music, so I reached out to Iggy to see if he wanted to work on the song with me. When he agreed, I was beyond excited.

I flew to Miami, and as I was walking into the studio to meet Iggy, I completely lost it. I was about to work with one of my idols. I had never before been starstruck like that.

Iggy was as cool and crazy as I could have imagined, and he was ready to get to work. He had already written a few verses for the song. My favorite included a line about cockroaches having sex in a garbage can. At one point, he began freestyling over a beat about rock and roll and frogs; his mind works in sick, brilliant ways. By the end of the day, we were old friends.

Iggy told me stories about touring and recording and bikers and partying in the sixties and seventies, and I soaked it all in. He told me that I had a nice pair of pipes, so the next time someone criticizes my voice, I'm just going to remember that Iggy Pop likes it, so fuck it.

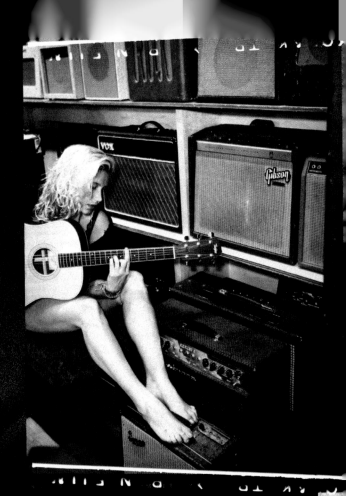

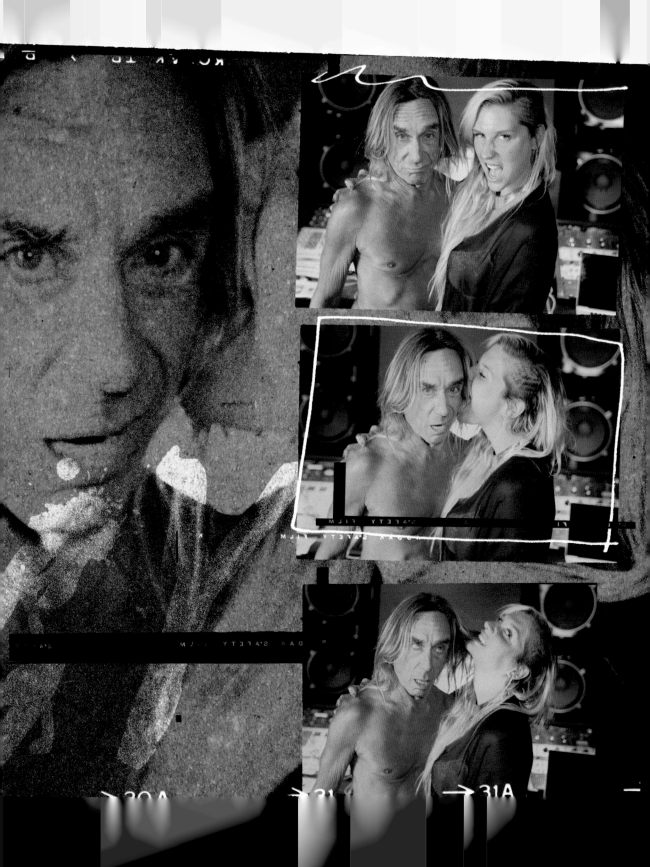

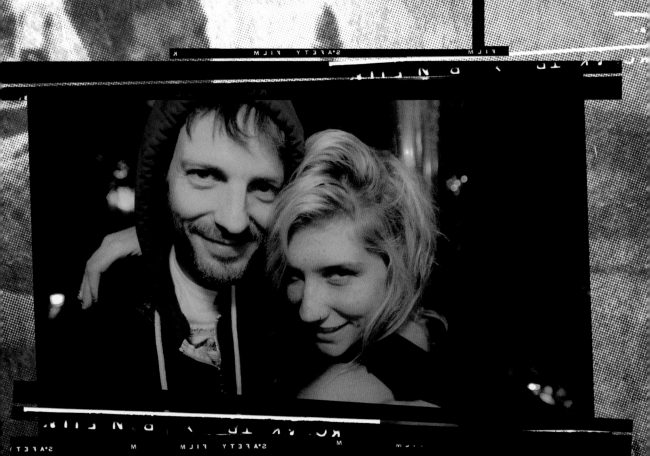

After writing and experimenting with a number of people, I was ready to get back into the studio with Dr. Luke, where I knew that a majority of the album would be made. I've been working with Luke since I was seventeen, and this next record was almost as important to him as it was to me.

"Every song needs to be great," he told me. "If you come out with an album full of songs that perform well, then you will solidify your career."

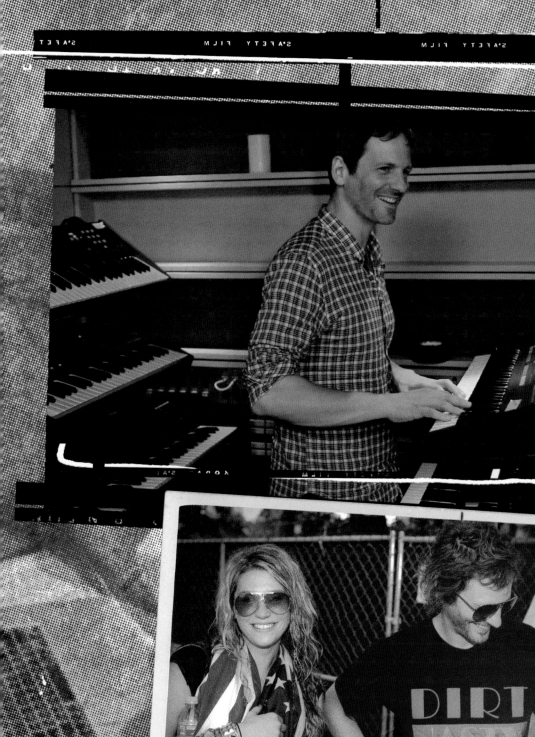

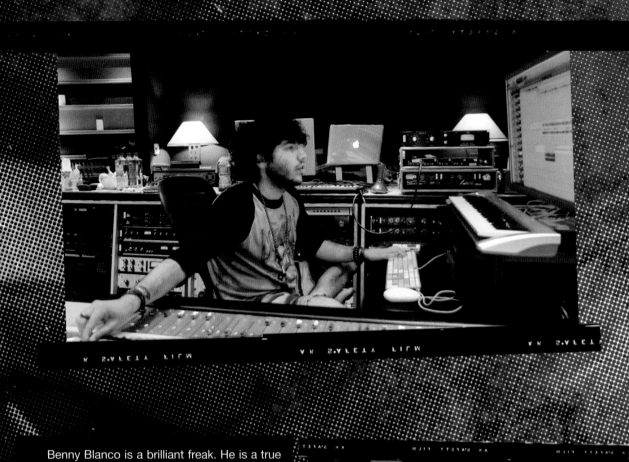

Benny Blanco is a brilliant freak. He is a true weirdo: he's not faking it, and he's one of the kindest people I have ever met. Getting back into the studio with Benny was a lot of fun because we just get stupid.

I have no idea how we ever get anything done because it seems as if all we do is talk about vintage T-shirts and boners. But as always, on this record Benny had some tricks up his sleeve.

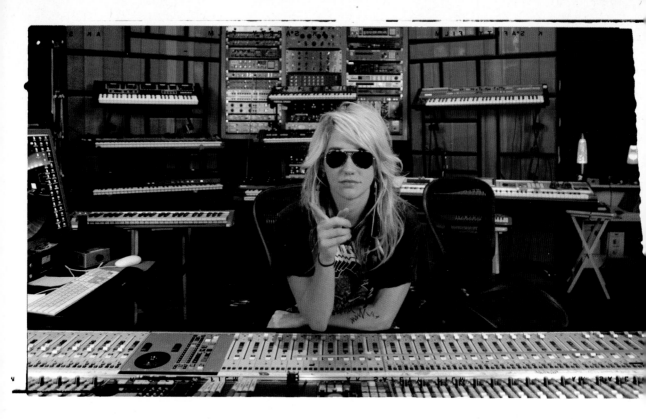

Luke is like a good coach. He is always pushing me and challenging me to get better. We put in a lot of hours in the studio. Every day I work until early in the morning. Often the sun is rising by the time I'm getting home. I will sometimes write and rewrite a song dozens of times before I get it right.

I never stop thinking about my songs. I often wake up in the middle of the night to write down lyrics or record ideas into my phone. Sometimes after spending days or even weeks on a song, we decide that it's just not good enough. One of the biggest lessons I have taken from Luke is that if you want to be among the best, you can't be precious with something just because you did it. The process can get frustrating, but I have high standards for my music, and if everyone doesn't love a song, then it's not good enough. Every song has to be undeniably good.

As I got into the writing with Luke, we had many creative discussions about what the direction of the album should be. One discussion was triggered by the song "Dirty Love," which I had worked on with Iggy Pop. Luke said he loved the song, but he was concerned that it wasn't the right sound for pop radio.

I agreed that I wanted my music to thrive on pop radio, and I explained that I wanted the music on the new album to embody the essence of seventies rock and roll, but I didn't want an album full of songs that sounded dated. I wanted to reinvent the sound, not copy it. We agreed that we wanted to try to create a sound that melded dance music and rock and roll.

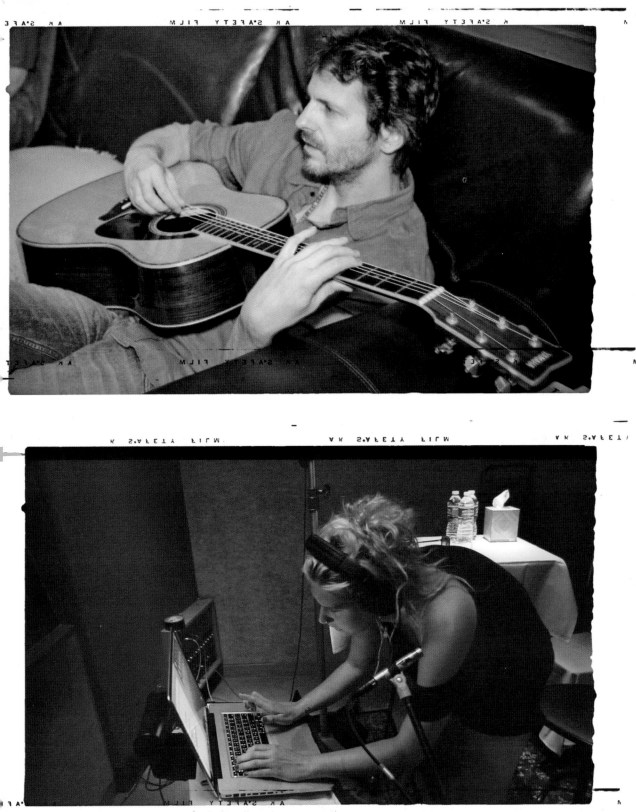

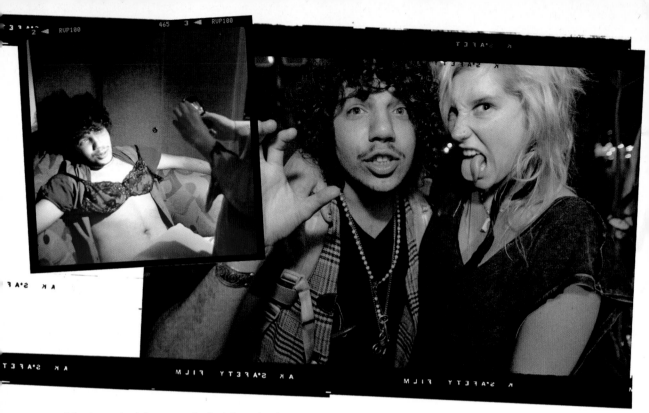

I had created the sounds that launched my career with Luke and Benny, and when I heard one track that they were working on with another of Luke's collaborators, Cirkut, it sounded as if it could be a new incarnation of "Tik Tok." They were calling it "Steak" because it was so thick and juicy. The chorus sounded blissful, and the verses were so heavy and nasty that it sounded as dirty as the dirtiest southern rap. I loved it.

Many of the songs I had worked on so far for *Warrior* were heartfelt, inspirational, and reflective, but when I heard this new track, I wanted to party. I wanted to write a massive party anthem that would get the whole world moving. We were looking for a hook and listened to the song over and over. Will.i.am from the Black Eyed Peas was working in the same studio and heard the song echoing down the hallway. It caught his ear, and he wanted to know what it was. Will.i.am started vibing to the song, and almost on the spot, we came up with the hook.

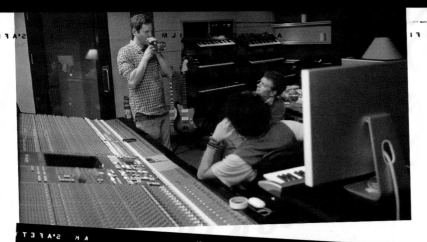

Hello wherever you are
Are you dancing on the dance floor or drinking by the bar
Tonight we'll do it big and shine like stars
And we don't give a fuck
Cause that's just who we are
We are the crazy kids
We are the crazy people

It sounded good. There was no denying it. I was recording the verse and Luke had an idea. "Try whispering the last line," he said. I whispered, "We are the crazy people," at the end of this ascending chorus, and I sounded like a crazy cult leader. I loved it. I worked on the verse to make sure that it sounded right. I didn't want this song to sound pretentious. I just wanted to write about being young and wild.

Listening to this song, I felt the gang was back together again in full force.

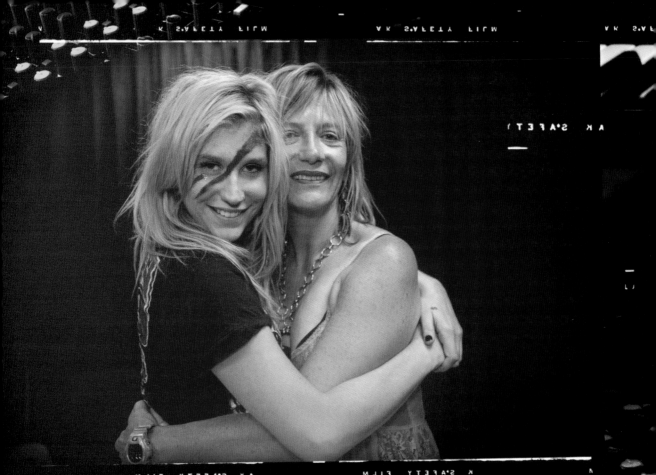

My mom and I wrote a lot together for *Warrior*. Writing with my mom is different from writing with anyone else because she knows me so well; no idea is too crazy. One would think that I would be the crazy one and she would rein me in, but it's often the opposite. When we wrote "Cannibal" together, she came up with some of the more gruesome lines. On one song we worked on for *Warrior*, my mom suggested a line about sexual exploits with the *Sesame Street* characters Bert and Ernie. My mom is one of a kind.

My mom and I teamed up with Ammo, whom we worked with on "Your Love Is My Drug," to write one of my favorite songs on *Warrior*. Ammo had a dance track that sounded fierce. I wanted to say something that I felt passionately about because the track sounded so intense. "No One's Getting Out Alive."

That was it. I knew that was the title as soon as I heard it. My mom and I wrote the song over two days with Ammo. This is one that I can't wait to play live because every word just feels so right.

I'm
standing on my own two feet
somewhere hanging in between
my life and the death of me

fate
doesn't leave us time to waste
wearing through the human sac
till we run out of air to breathe

no one is getting out alive
all the gold on earth it won't buy time
so we might as well give up the fight
live it up tonight
no one's getting out alive

After about a month of working with Luke on *Warrior,* we already had about thirty song ideas. I was coming up with more and more as fast as ever. Luke was concerned that if we kept on creating new songs, I could burn out and not have the creative energy to finish the album the right way. He told me that I also needed to understand that the more songs we wrote, the more songs we would end up having to cut from the album.

Whatever the risks, I wasn't ready to stop writing new songs and stop experimenting with more sounds. My number one goal was to make the best album possible. Anything short of that wasn't good enough. So I kept on writing.

ENTERTAINMENT
REAL
CLICHÉ
interesting

— like there were young?
— promise me you that do
— two in our past do
— would even leave if
— maybe thought those
— nothing stays the same
even though wouldn't
did when we were kids
nothing even they'll never be a
love that hurts me like the
first one did
there just won't be a place

Some things hurt to say outloud but there I said it
sometimes the ~~taste~~ it wears off and underneath
maybe when fantasy all of the magic
I was just lost and needed someone to

legacy outlast it

I got this question yeah
its been burning thru my head
who's teaching that
...

Dear Diary 1

the mind truth is powerful
the human facade is

Jesus on beauty

NARCISSIS

heaven or hell

when were ~~all~~ dirty
to live forever
I'm sick of dying
I'm sick
the realization of death
me screamed
were dying & out of time
me

① me like a criminal
lets lose control lets love
criminal
kiss me like a

(come on
be moon full
me where I wanna
② baby touch me tell
(love) for
tell me what ur waiting
or lives
be the best night of

BACK TO WONDER

WHERE IT ALL BEGAN
EVERYTHING WAS SO SIMPLE THEN

I did most of the writing and recording for my album in LA. When my twenty-fifth birthday rolled around, all of my friends from the days of slumming around Echo Park threw me a party.

It was a fun night. So fun that I decided to get a tattoo in red ink that simply read FUN. My friends know how to have a good time and it got wild. The party brought back so many memories.

The next time I was in the studio, I came up with a song, an ode to that time in my life and my old friends who will always remind me of those broke years in LA before I made it.

LIVING LIFE LIKE OUT LAST WEEKEND

WISH I COULD FIND MY WAY

BACK TO WONDERLAND

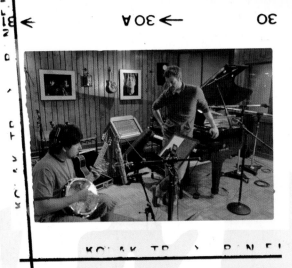

COME AND CLIMB INTO MY GOLDEN COCKPIT
LOVE YOU TILL YOU'RE SEEING STARS AND STRIPES
BURNING RUBBER ON THE SOUTHERN HIGHWAY
I'M GON' TAKE YOU FOR A FREEDOM RIDE

After working in LA for months, I brought Luke to Nashville to work. Even though I've spent so many of my formative years in LA, Nashville is where my soul's at. I especially love Nashville in the summertime. Shirts and shoes are almost always optional. There is no better southern holiday than spending all day at the lake jumping off cliffs, riding Jet Skis, and flirting with bearded boys in your favorite Budweiser bathing suit. It makes a girl proud to be from the South.

We got into the Nashville groove and invited some amazing local musicians to come play on my record. Yes, there is banjo on *Warrior*. While in Nashville, my mom and I teamed up with another of my favorite collaborators, KoOoL kOjAk. We wrote another badass song, inspired by my car, called simply "Gold Trans Am." It's a metaphor for my hoo-ha.

WHAM BAM THANK YOU MAN,

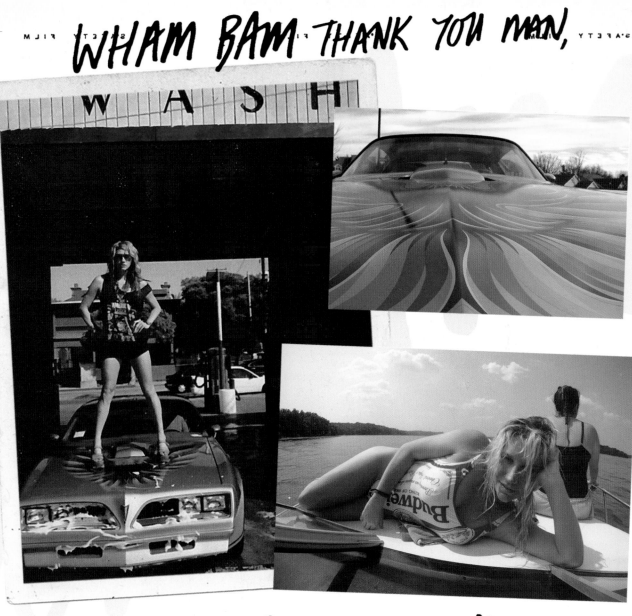

GET INSIDE MY FUCKIN GOLD TRANS AM
GET INSIDE MY FUCKIN GOLD TRANS AM

Toward the end of the recording for *Warrior* we started to really figure out how to meld the sounds of rock and roll and dance music. That's when "Die Young" was born. I was trying to channel the Rolling Stones and Neil Young, but also make it sound electronic and danceable at the same time. I worked on the song with Nate Ruess, the lead singer from the band Fun., as well as Benny and Luke. The song has a really organic sound, and I love the way it explodes into a party track. We recorded the song at Luke's house and did group vocals for the sing-along bridge together in Luke's garage. I rewrote the words a thousand times until I found something simple that felt right.

The song captured the underlying message of the whole album: believe in yourself and celebrate life to its fullest. When I sing "Like we're gonna die young," I'm promising that no matter how old I get, I'm never going to lose my youthful spirit.

Die Young

Lookin for some trouble tonight, yeah
Take my hand I'll show you the wild side
Like it's the last night of our lives
We'll keep dancing till we die

I hear your heart beat to the beat of
 the drums
Oh what a shame that you came
 here with some one
So while you're here in my arms
Let's make the most of the night
 Like we're gonna die young

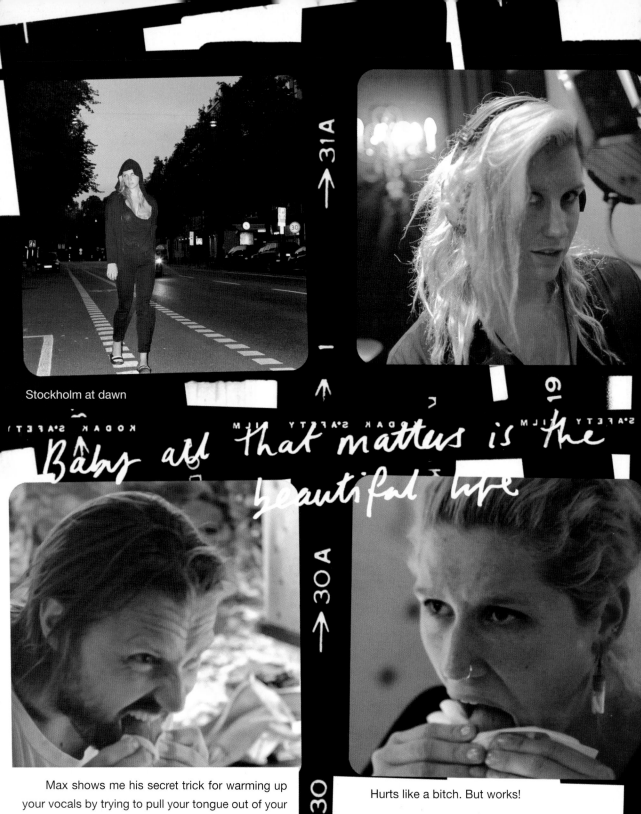

Stockholm at dawn

31A

19

Baby all that matters is the beautiful life

30 A

30

Max shows me his secret trick for warming up your vocals by trying to pull your tongue out of your mouth.

Hurts like a bitch. But works!

We're made of stars
We're up in space
Now in the dark
Come kiss my face
We're swimming in gold
We're swimming in gold
So fuck it we don't care

Baby all that matters is the
beautiful life

STAN LECKER · BEAUTIFUL LIFE

The lights are off
It's time to play
Got work to do
But that can wait
I'm bout to let go (It's time to let go)
Let everyone know
That fuck it, I don't care

Been spending too
Much energy
On stupid shit
When honestly
I wanna get high
Just wanna get high
With everyone else here

Baby all that matters is the beautiful life X 234

We're made of stars
We're up in space
Now in the dark come kiss my face
We're swimming in gold
We're swimming in gold
So fuck it we don't care

This just got sick
Before my eyes
Gon' stay up here till
the end of time
I feel so alive
I'm loosing my mind
everyone else here

Baby all that matters is the beautiful life X 234

So turn it up yea turn it up
It's never going to stop

I WANT

When we were almost done with the record, I got a call from Max Martin saying that I should come to Sweden to work on a song idea he had. Max is one of my favorite people to work with in the world, so obviously I jumped at the opportunity and hopped on a flight.

Sweden is such a beautiful place. I love going there.

Even though I hadn't slept in two days I was so excited to work with Max that I went straight into his studio. We ended up writing the whole song in a few hours. "Beautiful Life" is about not letting the daily bullshit that everyone deals with bring you down. I sometimes find myself dwelling on small daily problems for hours or even days on end, and I wanted to write this song as a reminder to try not to get hung up on imperfections and forget how beautiful this life is even if it's not perfect. When you are out having a good time, just go for it! I was inspired to write this song while remembering one magical weekend I had with all of my friends at Coachella.

Recording *Warrior* was the most challenging and rewarding thing that I have ever done. I got to work with some of the most inspiring musicians in the world such as Wayne Coyne from the Flaming Lips and Patrick Carney from the Black Keys.

When I set out to write this record, my biggest challenge was that I knew I had to live up to my fans' expectations. When I finished it, I had no idea if anyone in the world would like it . . . but I knew that I had put every ounce of myself into it. That's all I can do. I hope you like it.

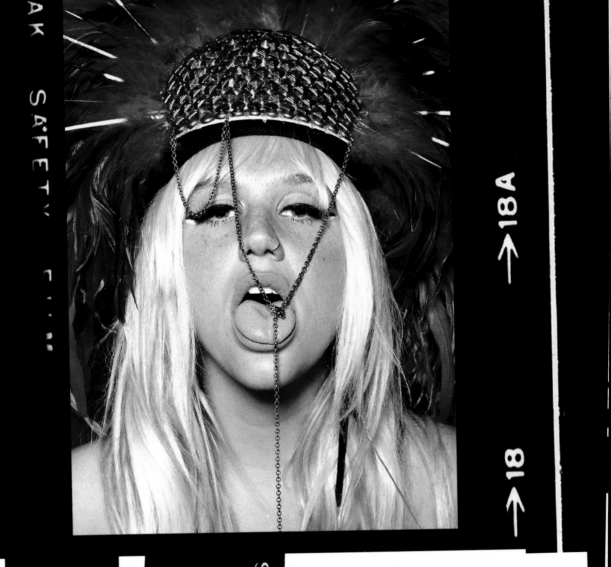

My first album was called *Animal* because at the time I lived like a wild primal creature driven by visceral urges and emotions. I named my sophomore full-length album *Warrior* because though I am still wild and fun loving, I've grown over the last few years. Now that my life is more complicated I have learned to focus that wild energy. Like everyone else in the world I have fears and doubts, but to me a warrior is someone who can overcome anything. To me a warrior is an animal who has been challenged but has stayed true to himself or herself.

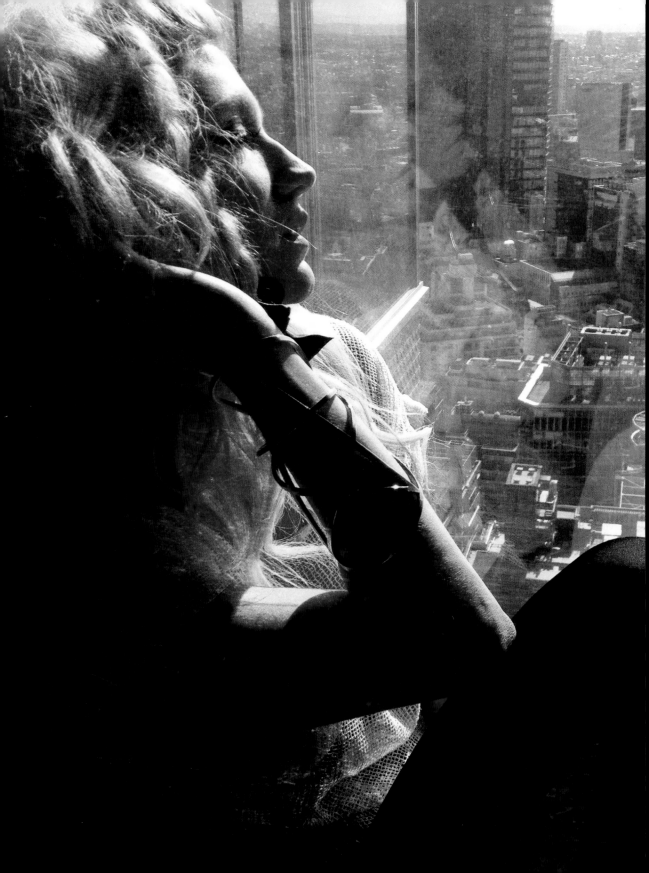

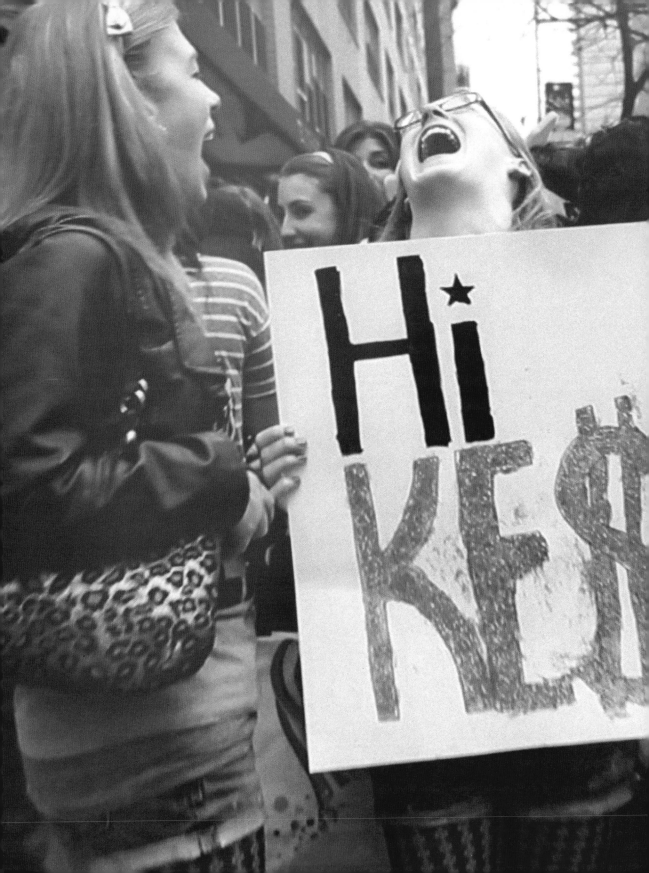

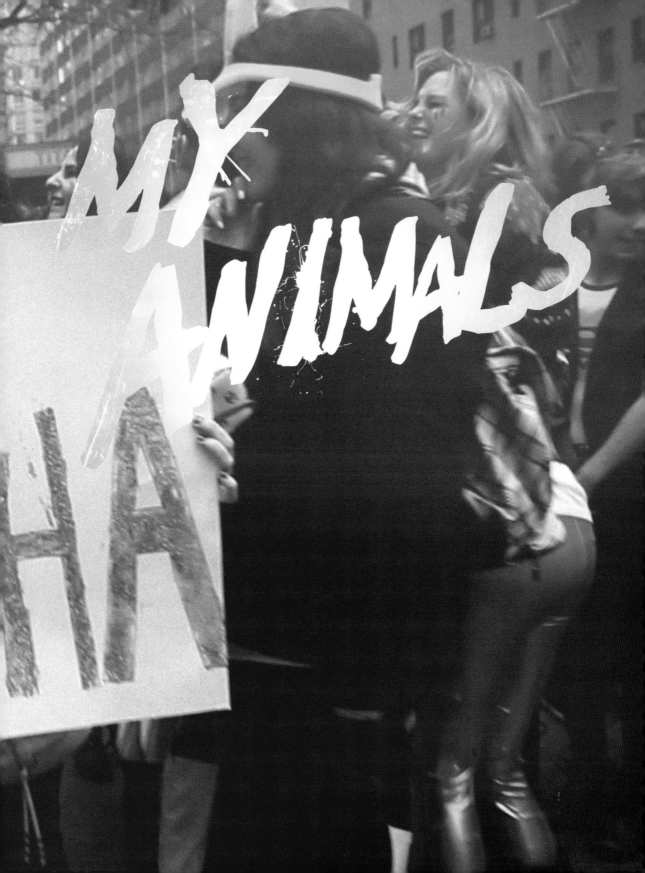

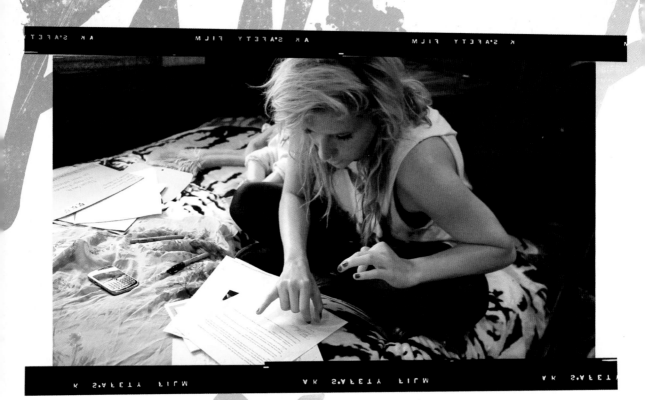

I owe every moment of this crazy beautiful life to my fans. Whenever I get lonely on the road, I turn to the amazing letters I've received from my fans and it instantly puts me in a better mood. They are the first people I think about when I wake up and the last people I think about before I go to sleep. If I go to sleep, that is . . .

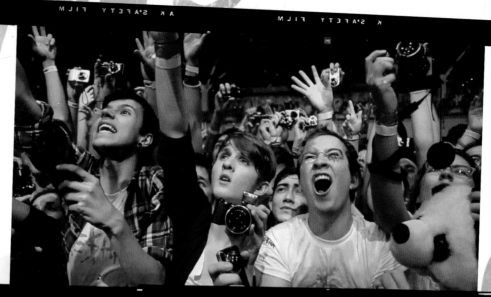

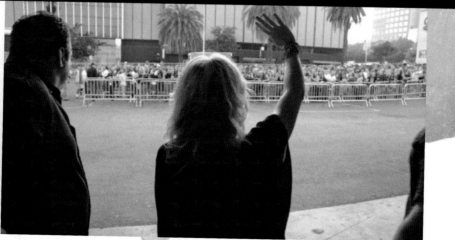

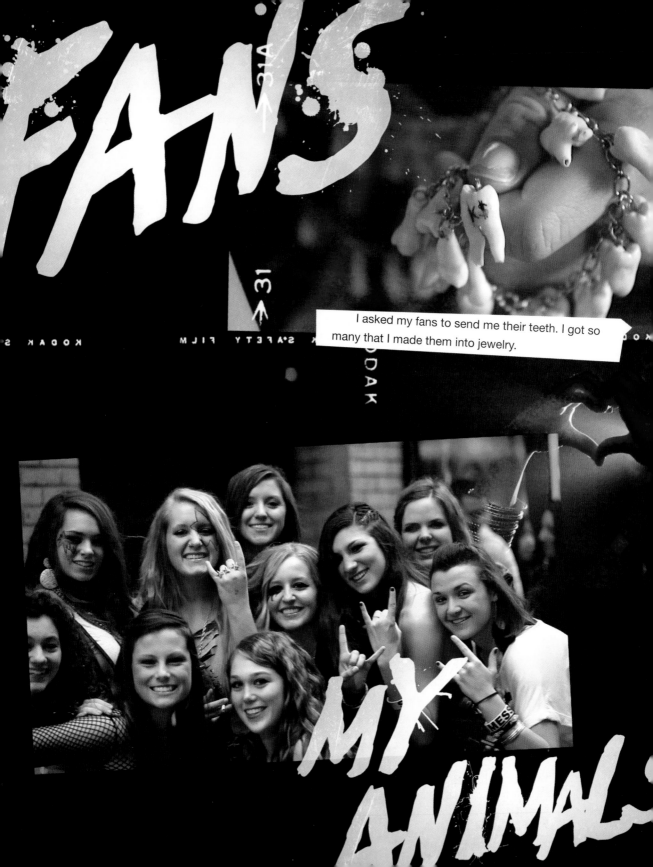

FANS

I asked my fans to send me their teeth. I got so many that I made them into jewelry.

MY ANIMALS

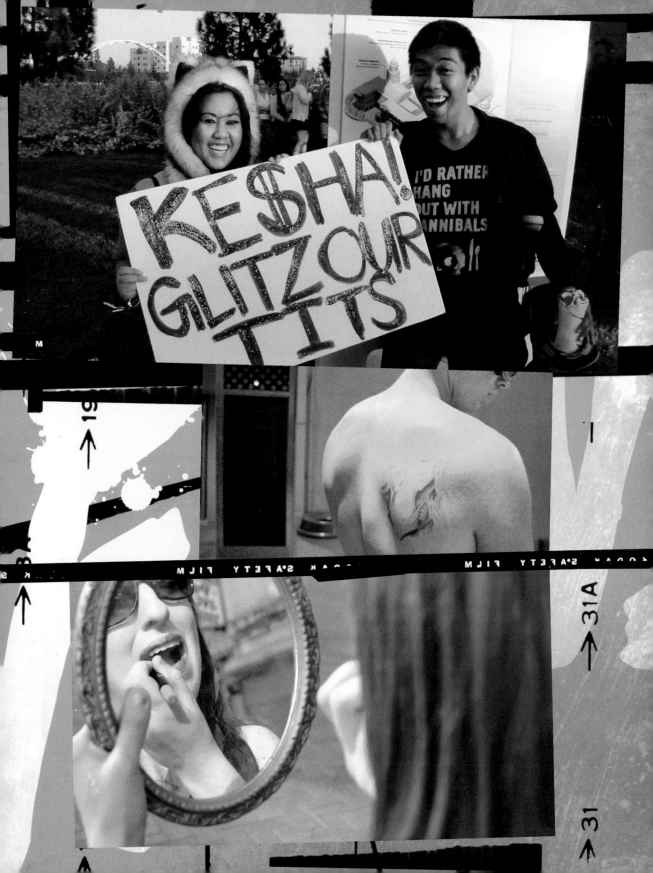

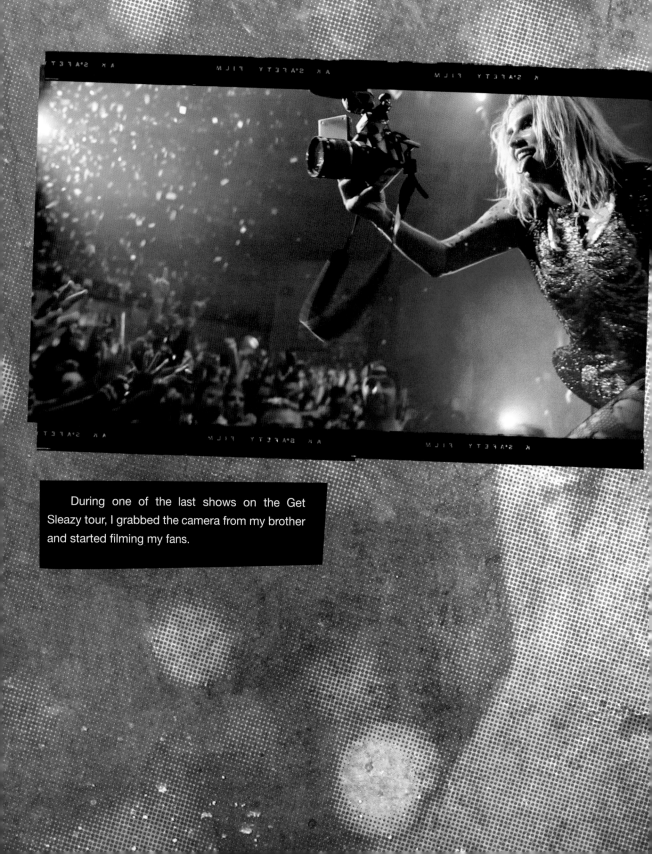

During one of the last shows on the Get Sleazy tour, I grabbed the camera from my brother and started filming my fans.

Animals, you mean everything to me. I hope you'll keep believing in me, because I'll never stop believing in you.

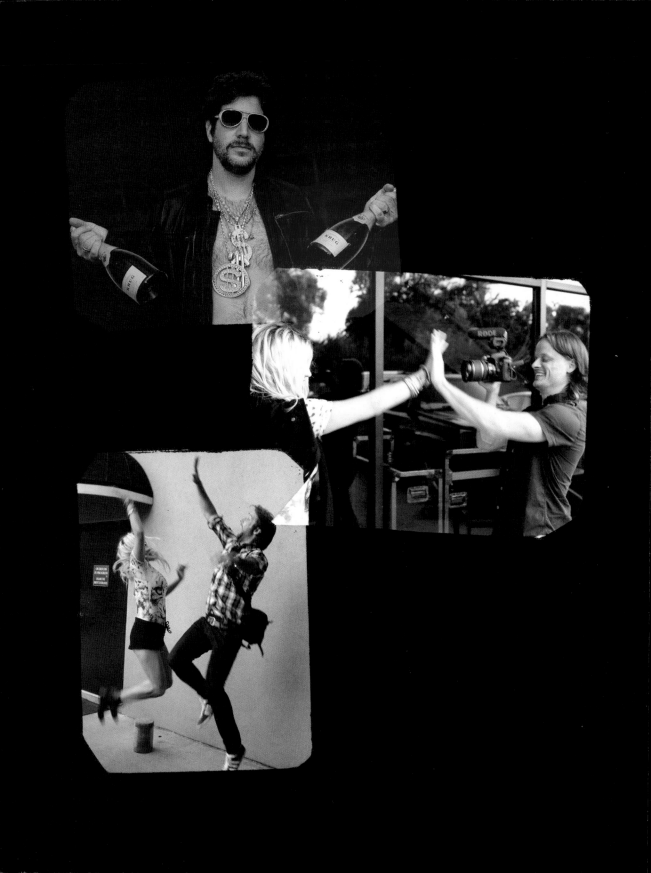

ACKNOWLEDGMENTS

This book was a group effort and a very personal project for myself and my family. Special thanks to my mom for everything she does for me: for birthing me, teaching me my craft, always being supportive, and coming all over the world with me. My mom and my aunt, Sonia Sebert, opened up the family archives to find some of the amazing photos included in these pages and spent days converting them to digital files. My cousin Kalan spent hours digging through old shoeboxes of photos and even my little brother, Louie, got into the action to help out.

Thanks to my managers Jack Rovner, Monica Cornia, and Ken Levitan, without whom all of my crazy ideas would be simply that: crazy ideas . . . And thanks to Dr. Luke and all of the incredible musicians I work with for helping me realize my dreams and believing in me.

Thanks to Jason Sheldon, who took so many of the awesome photos included in these pages, especially the ones from the early days. It's a special photographer who knows how to capture the essence of a moment in one snap.

This book is a labor of love that I dreamed up with my brother a few years back. My brother was working as a journalist when I was just getting started on this crazy roller-coaster ride and we both decided that I had a story worth telling. My brother and his wife, Sandra Sampayo, gathered up some friends, Steven Greenstreet and Ted Roach, and set off on a journey around the world with me. They took hundreds of hours of footage and took thousands of pictures. For a while there, it seemed like Steven and his camera were physically attached to me. Even though I like to tease him, Steven's one of the hardest-working creative people I know.

Thanks to everyone who makes this crazy beautiful life possible.

PHOTO CREDITS